*The Campus History Series*

# GWYNEDD-MERCY COLLEGE

D1548585

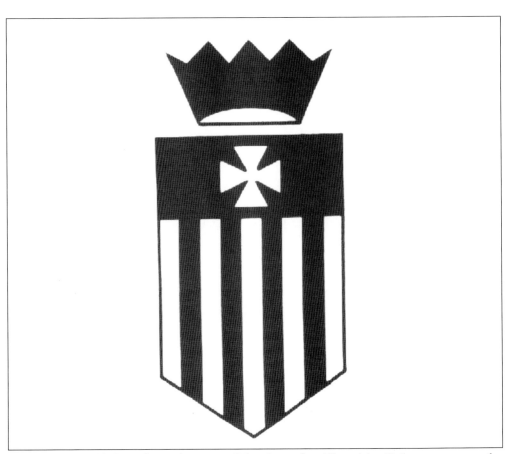

The Mercy Shield dates from the time of the Crusades. The white Maltese cross on the upper section reflects special service to the sick in hospitals. The four red stripes on the lower portion are symbolic of bloodshed during the ransom of captives. King Louis the Pious of France (AD 813–840) dipped his hand into the wounds of Count Godfrey the Rough and drew four stripes on Godfrey's gold shield. The Order of Mercy, founded in 1216 in Spain, was given the shield by James of Aragon to honor and protect its members. The gold crown of Aragon surmounts the shield. When Catherine McAuley founded the Sisters of Mercy in 1831, she noted the similarity in works of the 13th-century monks and the Sisters of Mercy and adopted the Mercy Shield as a standard for the congregation.

*On the cover:* Three students enter Assumption Hall in the 1950s. (Courtesy of Gwynedd-Mercy College Archives.)

*The Campus History Series*

# GWYNEDD-MERCY COLLEGE

Bond Centennial and Heritage Committee
and Marion K. Rosenbaum, Archivist

ARCADIA
PUBLISHING

Published by Arcadia Publishing
Charleston SC, Chicago IL, Portsmouth NH, San Francisco CA

Printed in the United States of America

Library of Congress Catalog Card Number: 2005938517

For all general information contact Arcadia Publishing at:
Telephone 843-853-2070
Fax 843-853-0044
E-mail sales@arcadiapublishing.com
For customer service and orders:
Toll-Free 1-888-313-2665

Visit us on the Internet at http://www.arcadiapublishing.com

# CONTENTS

# ACKNOWLEDGMENTS

My thanks to the Bond Centennial and Heritage Committee, cochaired by Sr. Catherine McMahon and Gerald McLaughlin (vice president, Institute of Advancement), and to Gloria Pugliese, cochair with me of the History Sub-Committee. Special thanks to Sr. Mary Colman, who organized a picture identification group, and Drs. Michael Clinton, Wayne Huss, and Wade Luquet, who supported this project from the beginning. Much credit goes to the many photographers associated with the Religious Sisters of Mercy, Gwynedd-Mercy Academy, and Gwynedd-Mercy College: Ben Weiner, Shirley King, Sr. Fran Regan, Joseph Durinzi (Carl Wolfe Studio), Carl Gachet, Robert S. Halvey, L'Image Studios, Photography Department of the Mercy Catholic Medical Center, Jim Roese, and Charles F. Sibre. Additional thanks to faculty and staff at Gwynedd-Mercy College for taking the time to review archives material and add to our collection: Tom Friel, Carol Evans, Dr. Jules Tasca, and the Mercy Volunteer Corps office.

In order to accurately describe and put images in historical context, there were many conversations with descendants of the Bond and Taylor families and organizational contacts: Barbara Harvey (GMA/Elementary Division), Karen Benson (GMA/High School Division), Sr. Joan Freney (Sisters of Mercy of Merion Archivist), Eileen Mathias (Academy of Natural Sciences), Jeff McGranahan (Historical Society of Montgomery County), Karen Lightner (Free Library of Philadelphia), Francis G. Lawson, the Lower Gwynedd Township Office, Maria McHugh, Diane Rzegocki, and Clare Yellin. David Contosta and Pat Ingersoll were most helpful in making their own research and collections available and for suggesting new areas for research.

Final tributes go to Sr. M. Henrietta Connelly for creating an archives in the late 1980s and to Eleanor King, previous archivist, for her endeavors in the 1990s. Donna Smyrl, Rebecca Yearsley Signore, and Barbara McHale coordinated with Erin Vosgien, Arcadia publications editor, to bring this publication to press.

# INTRODUCTION

In 1945, the Sisters of Mercy petitioned the Pennsylvania Department of Education to establish a private junior college. The Sisters of Mercy, who had arrived in Philadelphia in 1863, also resolved to move their academy from its Broad Street location in Philadelphia. It became the mission of Mother Mary Bernard Graham, Religious Sister of Mercy (RSM), to find a suitable location to house both the academy and the anticipated college. She found this location at Treweyrn Farm.

At the time of the purchase, the property was owned by the Hardwick family; however, the property had originally belonged to the Bond family, who built the Georgian mansion and gardens and named their home Willow Brook. The Taylor family, who owned the home after the Bonds, christened it Treweyrn. The Sisters of Mercy purchased 84.5 acres of the property from Roland Taylor's daughter Marjorie Hardwick for $100,000 on May 10, 1947. Included in the purchase were the manor house (now Assumption Hall), the stables (now Byrne Hall), a formal garden, a tenant house for the gardener, a garage, a greenhouse, and a small laundry building. Almost immediately, preparations were underway to make the property an operational educational institution.

Gwynedd-Mercy Junior College officially opened on October 1, 1948, with the arrival of 28 young women. The programs offered reflected the mission of the Sisters of Mercy and would allow the students "to care for the poor, the sick, and the ignorant." During the 1950s, the college experienced phenomenal growth. Additional property, on the estate and elsewhere, was purchased for housing and instructional use. At the close of the decade, Lourdes Library was dedicated, the college received accreditation, and enrollment reached 218 students.

In 1963, the college received approval to award baccalaureate degrees. This change paved the way for four-year programs in allied health, education, liberal arts, and business, which would play a role in shaping the college's legacy. Today Gwynedd-Mercy College offers undergraduate and graduate degrees, as well as a variety of certificate programs. A number of instructional and residential facilities have been added to the campus to accommodate a burgeoning student population, including Alexandria Hall, a residence facility which opened in early 2006. With a student to faculty ratio of 13 to 1, it is clear that the growth of the college has not affected the level of care and attention that students receive.

Further, the traditions of the Sisters of Mercy are carried out each day in the many ways that the college touches the community. Students serve the community in the tradition of the Sisters of Mercy, who, along with their associates and colleagues, provide spiritual support services in a variety of settings and serve in numerous ministries that provide housing and basic necessities for those who lack them. Apache children in San Carlos, Arizona; women in Chulucanas, Peru; residents of North Philadelphia; and persons

finding refuge at Women of Hope or Project HOME know Mercy through the work of Mercy Volunteer Corps, Mercy Associates, and members of the Gwynedd-Mercy College community who are committed to outreach and living the legacy of Catherine McAuley. Gwynedd-Mercy College remains an institution focused on its mission to educate the whole person so that each student is prepared for a career, literate in the liberal arts and sciences, and aware of the need for service to society.

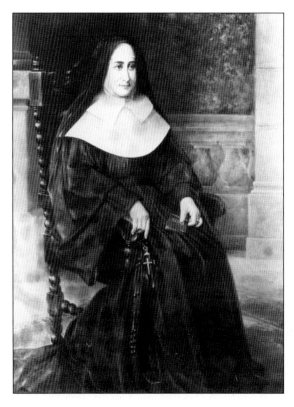

This picture of Mother Mary Catherine McAuley (1778–1841), founder of the Sisters of Mercy, is a photographic reproduction of a portrait that hangs in the Sisters of Mercy Convent in Merion. Copies are predominant throughout the Gwynedd-Mercy College campus. There were no photographs taken nor portraits painted of McAuley in her lifetime. The portraits that do exist are based on a description written by a Sister of Mercy who was an artist and McAuley's contemporary. McAuley's cause for canonization is under consideration by the Catholic Church. She was declared venerable in 1990.

# *One*

# SISTERS OF MERCY:
## DUBLIN TO GWYNEDD VALLEY

Catherine McAuley, born in Dublin, Ireland, in 1778, was influenced by her father's steadfast Catholic faith and concern for Dublin's poor. McAuley's devoted care for Catherine and William Callaghan, a couple who opened their home to her, resulted in her receiving a large bequest that would enable her to help those in need.

On September 24, 1827, the feast of Our Lady of Mercy, opened the House of Mercy at Baggot and Herbert Streets in Dublin to provide shelter and education for young women who came to Dublin seeking employment. Other women joined McAuley at the House of Mercy. Daniel Murray, archbishop of Dublin, witnessing the work of McAuley and her companions, suggested that she establish a religious community. On December 12, 1831, after completing a novitiate with the Presentation Sisters, McAuley pronounced her vows as the first Sister of Mercy.

In 1843, Mother Mary Frances Warde established the first Mercy foundation in the United States in Pittsburgh, Pennsylvania. In 1861, she agreed to send sisters to Philadelphia from the Manchester, New Hampshire, foundation. Mother Patricia Waldron and nine other sisters arrived at Assumption B.V.M. Parish in Philadelphia on August 22, 1861, to staff the parish school. Soon the sisters were also teaching in the academy and night school that they opened for working girls.

In August 1863, Mother Patricia Waldron had the opportunity to rent a house at Broad Street and Columbia Avenue. With $5 at her disposal, she signed a $600 annual lease. Her trust in God's providence was not unfounded. Eventually seven houses were purchased at Broad Street and Columbia Avenue for the sisters, the academy, and St. Mary's Home for Working Girls.

In 1884, Mother Patricia Waldron purchased a house on Montgomery Avenue in what is now Merion Station. Days after their arrival, the sisters began to teach the neighborhood children, and the forerunners to St. Margaret School in Narberth, Merion Mercy Academy, and Waldron Mercy Academy were established. In 1918, two years after the death of Mother Patricia, Misericordia Hospital (currently Mercy Hospital of West Philadelphia) and Misericordia School of Nursing opened. Fitzgerald-Mercy Hospital, Fitzgerald-Mercy School of Nursing, Mercy Suburban Hospital, and Gwynedd-Mercy College would follow and be joined by other Mercy institutions.

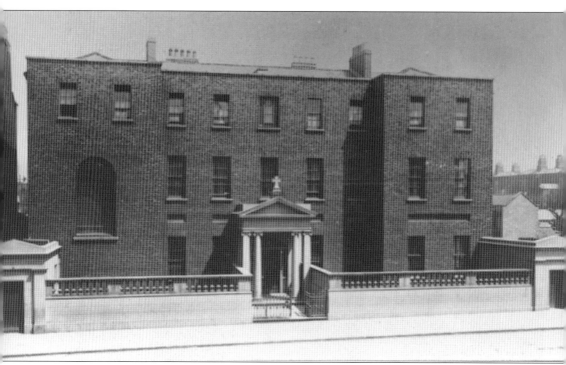

In 1824, Catherine McAuley leased property at Baggot and Herbert Streets in Dublin, Ireland, and used her sizable inheritance to build a house where poor children could be educated and young girls and women could find shelter. The House of Mercy, which opened on September 24, 1827, became the foundation house of the Sisters of Mercy in 1831. McAuley died at the Baggot Street convent on November 11, 1841, and was buried in the enclosed garden. In 1994, after extensive renovations, the Convent of Mercy was renamed Mercy International Centre. Hundreds of people tour the center each year and pray at McAuley's tomb.

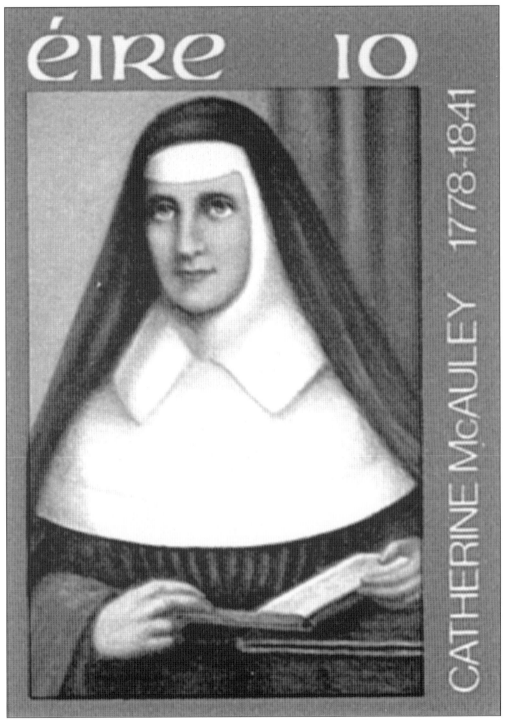

Another image of Catherine McAuley can be seen on this Irish stamp that was issued in September 1978.

11

Mother Mary Frances Xavier Warde was born in Mountrath, Queen's County, Ireland, in 1810 to John and Mary Warde. Her mother died soon after her birth, and Frances was raised by a maternal aunt. After a series of misfortunes and several deaths in her family, Frances arrived in Dublin in 1827 as a young woman and met Catherine McAuley through her friendship with McAuley's niece Mary. Frances was professed by McAuley as a Sister of Mercy on January 24, 1833. She eventually came to the United States in 1843 and is considered the American founder of the Sisters of Mercy, having established the first Mercy foundation in the United States on December 12, 1843, in Pittsburgh, Pennsylvania. Mother Mary Frances died in 1884 and is buried in Manchester, New Hampshire.

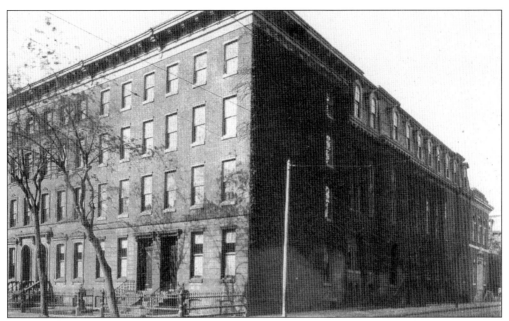

The Academy of the Sisters of Mercy opened in 1861 at 1135 Spring Garden Street and was located for a short period of time at St. Malachy Parish at Eleventh and Master Streets. In 1863, the academy moved to Broad Street and Columbia Avenue, shown here. Seven row houses on Broad Street housed the sisters, the academy, and St. Mary's Home for Working Girls.

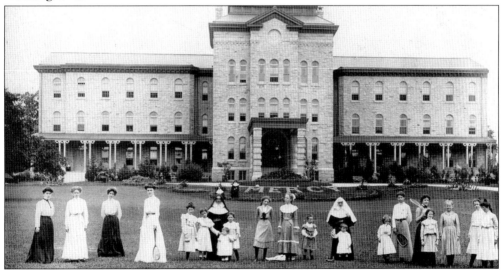

In 1884, the Sisters of Mercy purchased a small house and eight acres of land on Montgomery Avenue in what is now Merion Station. One year later, they purchased an adjoining 20-acre property, which included a large stone house and a small farmhouse. Within a few years, these buildings were too small to house the sisters, Mater Misericordiae Academy, and St. Isidore's Village School. The center section of Mater Misericordiae Convent and Academy, pictured here, was completed in 1893. By 1906, two four-story wings and a chapel/auditorium building were added to what now serves as the Motherhouse of the Sisters of Mercy of Merion.

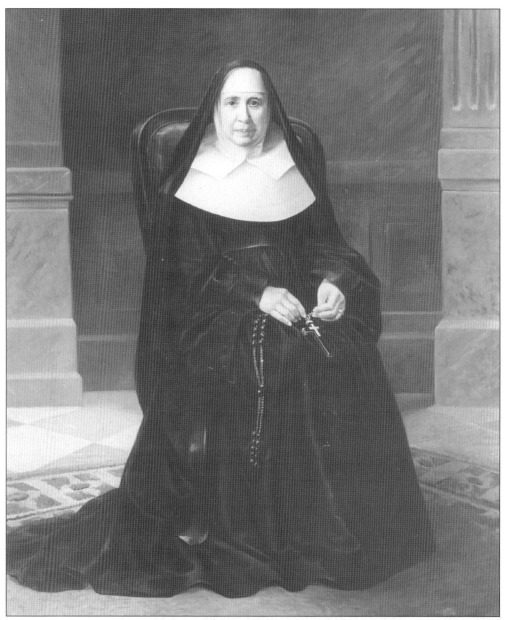

Anne Mary Waldron, later known as Mother Mary Patricia Joseph Waldron, was born in Tuam, County Galway, Ireland, in 1834. She entered the Convent of Mercy in Ballinrobe, County Mayo, in 1852 and professed her vows as a Sister of Mercy on July 20, 1855. In 1860, Mother Mary Frances Warde requested that a sister be sent from Ballinrobe to Manchester, New Hampshire, to assume the role of mistress of novices. Sr. Mary Patricia Waldron was selected. One year later, the young and very capable Mother Mary Patricia was called upon to establish the Philadelphia foundation of the Sisters of Mercy. She was superior of the Philadelphia (Merion) community until her death on July 30, 1916.

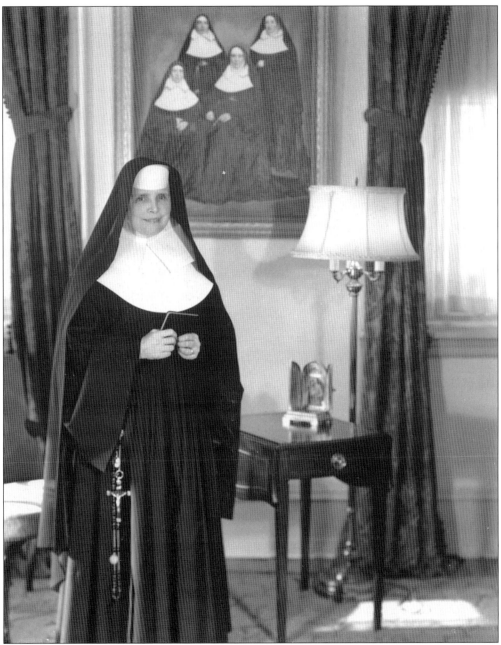

Mother Mary Bernard Graham, the first president of Gwynedd-Mercy Junior College, stands below a portrait of (seated left) Mother Mary Gertrude Dowling, (seated right) Rev. Mother Mary Patricia Waldron, (standing left) Mother Mary Hildegarde Heuser, and (standing right) Mother Mary Bernard Collins. Mother Mary Bernard Graham, the Mother General of the Sisters of Mercy (1945–1951 and 1958–1970), was responsible for moving Gwynedd-Mercy Academy to Gwynedd Valley and initiated the opening of Gwynedd-Mercy Junior College.

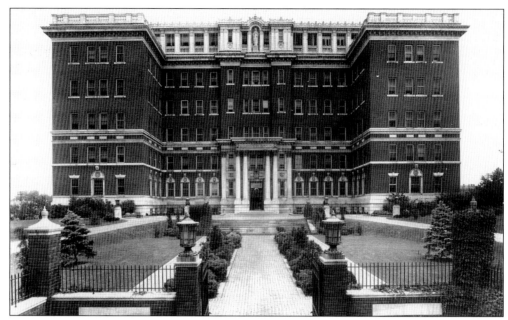

Misericordia Hospital opened in 1918 at Fifty-fourth Street and Cedar Avenue. Mother Patricia Waldron had long dreamed of building a Sister of Mercy hospital in Philadelphia. She mortgaged the Broad Street property to buy the land in 1914 but died two years before her dream became a reality. What she could not know was that Sisters of Mercy health care would continue for many decades and extend far beyond Misericordia Hospital to what is now known as Mercy Health System.

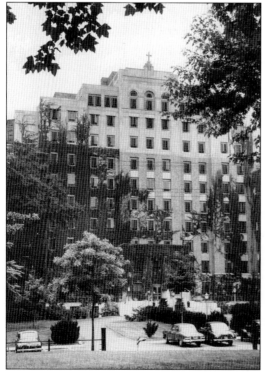

The administration of Fitzgerald-Mercy Hospital in Darby, Pennsylvania, was given to the Sisters of Mercy in 1933. This hospital had been built according to the will of the late Thomas M. Fitzgerald. Mother Mary Edmonda Prendergast became the first administrator. Gwynedd-Mercy College would later offer courses here on its Edmonda campus.

# *Two*

# EARLY CAMPUS HISTORY:
## WILLIAM PENN TO THE TAYLORS

Native Americans were the first to carve a path through the woods that later became Sumneytown Pike. Archeological excavations done on campus in the 1970s showed evidence of possible Iroquois and Six Nation tribes in the area. However, the name that came to identify the area was given by Welsh settlers, who named the area Gwynedd, meaning "white" in the Welsh language. The earliest of land deeds in this area show transfers of land from William Penn to early settlers. One Welsh family, the Evans family, settled in the area that is now the college campus; the Evans' home is now St. Joseph's Convent, and Evans Road honors this family's name.

Germans also settled in the area. In the early 1840s, George H. Danenhower owned a large farmhouse with a barn, outhouses, a long driveway from Sumneytown Pike, and a back driveway to old Bethlehem Pike. His son, Charles, lived in a house adjacent to the back driveway, and his daughter, Phebe Ann, moved into the former Evans' house at the intersection of Evans Road and Sumneytown Pike after marrying Samuel Beaver.

Besides the Welsh and German families that settled in the area, English families also established homes in Gwynedd Valley. By 1892, Francis E. Bond was attracted to the area when his sister, Adelaide Josephine Bond, married into the prominent Ingersoll family. Francis bought the famous Spring House for which the area is named, now located behind today's Lower Gwynedd Township building. He would later commission noted architect Horace Trumbauer to build Willow Brook in 1906 on the former Danenhower property.

The Francis Bond family lived in Willow Brook only four years when Mrs. Bond died. After his wife's death, Francis took an ornithology trip to Venezuela and upon his return, donated over 100 bird specimens to the Academy of Natural Sciences of Philadelphia. In 1914, he married an English woman and moved with his two sons, Francis Jr. and James, to England.

The next owner of the property was Roland Leslie Taylor, who occupied and enlarged the estate between 1914 and 1946 and renamed the mansion Treweyrn after the tributary to the Wissahickon Creek that flows through the property. A year after his death in 1947, the property was purchased by the Sisters of Mercy to house their academy and anticipated junior college.

This early home was built in 1702 for the son of Thomas Evans and his bride. Later Phebe Ann Danenhower married Samuel Beaver, who owned the house in 1897. Samuel Beaver and George Danenhower jointly sold property to Francis Bond in the early 1900s. A third bride, Elizabeth Taylor Ely, lived in this house in the 1920s. The Keon family held this house from 1945 until the Sisters of Mercy purchased it in 1958. It is now known as St. Joseph's Convent. In the back of this house is a treasured Sycamore tree estimated to be over 200 years old.

The Danenhowers lived on this property for about 50 years, farming the land. Two of their children lived nearby, and there were quite a few buildings situated at the end of a long tree-lined front driveway leading from Sumneytown Pike. The original farmhouse is now Visitation House, which once served as a convent and currently houses the offices of Campus Ministry.

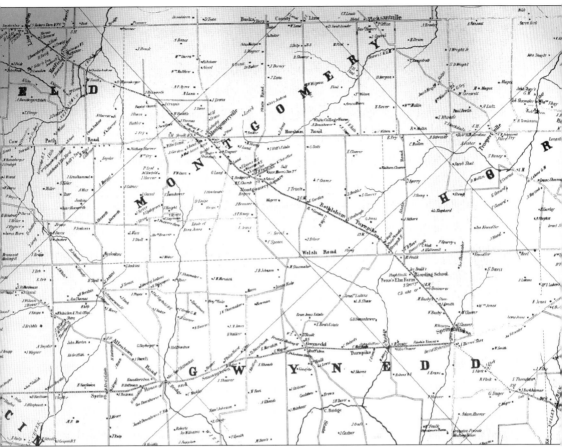

This image is a portion of an 1848 map of Montgomery County, Pennsylvania, from original surveys done under the direction of William E. Morris. The Spring House intersection is clearly marked. To the left is the name "George Danenhower," noted property owner at that time. Also shown is the tributary to the Wissahickon Creek that crosses the Gwynedd-Mercy College campus.

This house was erected around 1700 and was owned by the Cleaver family for more than 125 years. The stone house sits over a spring, which may be where the name "Spring House" originated. Francis Bond lived in this house in 1906, while waiting for his new mansion to be built, and then gave it to his Ingersoll nephew as a wedding present. It stayed in that family for over 80 years but is now owned by Lower Gwynedd Township.

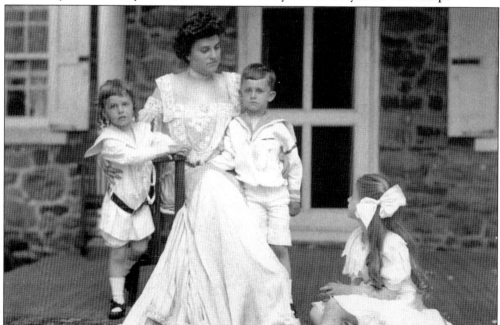

Margaret Reeves Bond (née Tyson) (seated) wintered at a home in Philadelphia but spent summers in Spring House, Pennsylvania, and in Isleford, Maine. Her daughter, Margaret (seated right), born in 1897, died tragically of a ruptured appendix in 1904 while the family vacationed in Maine. James (left), born in 1900, is approximately four years old in this picture, and Francis Jr. (second from right), born in 1898, is about six.

Francis E. Bond Sr. was born in Montevideo, Uruguay, in 1867, one of three children to Francis E. Bond and Sara Sarita Bond (née McCall). Little is known about his parents, but by the 1880s, Sara and the children were living in Germantown, Pennsylvania. Francis was an amateur ornithologist and shared his love of birds with his children. In 1912, he traveled to the Orinoco River area in Venezuela and upon returning, donated his field book and specimens to the Academy of Natural Sciences of Philadelphia.

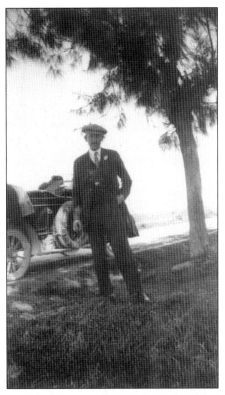

This building has a cornerstone of 1786, but it came to house the Penllyn Club in 1897. Francis E. Bond was one of the original members of this social club, which started as a polo club, became a golf club, and then emerged as a swim club. The Bond name can be seen on the charter hanging in the building. While living in the area, Cardinal Dougherty was an honorary member. This picture was taken during Lower Gwynedd's 1991 centennial year.

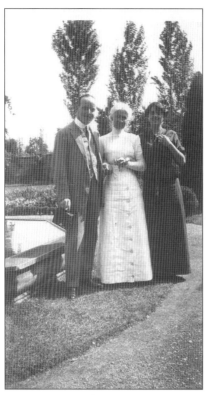

Adelaide Josephine Bond, sister of Francis E. Bond Sr., married Stephen Warren Ingersoll in 1882 but was widowed in 1884 when he died of typhoid fever. Her son, Edward, born that same year, would never know his father. In 1899, mother and son moved to Gwynedd with Adelaide's in-laws, Charles and Henrietta Ingersoll. This *c.* 1910 photograph depicts Edward Ingersoll (left) with his mother, Adelaide Ingersoll (middle), and his wife, Emily Vaux Ingersoll (right), in the garden behind Willow Brook.

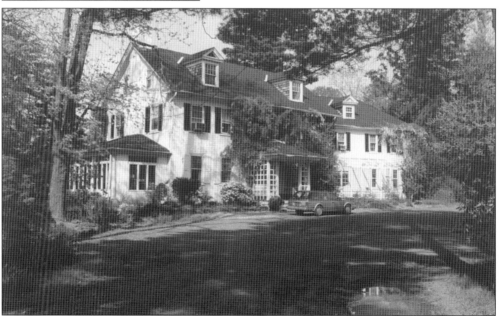

In 1909, approximately the same time that her brother Francis was completing Willow Brook, Adelaide Ingersoll (née Bond) built this house on Norristown Road, opposite today's Gwynedd-Mercy Academy/Elementary Division. It adjoined the farm of her son, Edward. This farmland has been developed in recent years with large homes, which are visible as one approaches the Spring House intersection from the east.

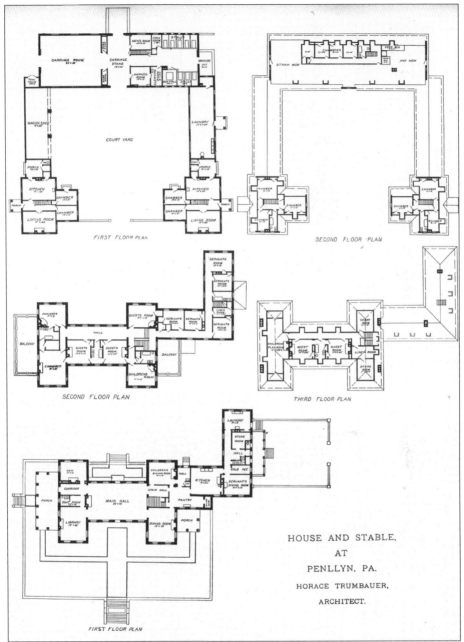

CARRIAGE HOUSE

CARRIAGE STAND

MEN'S ROOM

HARNESS ROOM

WAGON SHED

COURT YARD

LAUNDRY

PORCH

KITCHEN

CHAMBER

LIVING ROOM

MANURE

PORCH

KITCHEN

CHAMBER

CHAMBER

LIVING ROOM

FIRST FLOOR PLAN

STALLS

CHAMBER

CHAMBER

CHAMBER

SECOND FLOOR PLAN

STRAW MOW

CHAMBER

FEED BIN

HAY MOW

CHAMBER

CHAMBER

CHAMBER

SECOND FLOOR PLAN

SERVANTS ROOM

SERVANTS ROOM

CHAMBER

GUESTS ROOM

HALL

SERVANTS ROOM

SERVANTS ROOM

SERVANTS ROOM

BALCONY

GUESTS ROOM

GUESTS ROOM

BALCONY

CHAMBER

CHILDRENS ROOM

THIRD FLOOR PLAN

CHILDRENS PLAY ROOM

GUEST ROOM

GUEST ROOM

LINEN ROOM

STORE ROOM

CLEAN ROOM

LAUNDRY

STORE ROOM

HALL

COLD ROOM

DEN

CORRIDOR

PORCH

COAT ROOM

LIBRARY

MAIN HALL

CHILDRENS DINING ROOM

HALL

KITCHEN

STAIR HALL

PANTRY

SERVANTS DINING ROOM

DINING ROOM

PORCH

FIRST FLOOR PLAN

HOUSE AND STABLE,

AT

PENLLYN, PA.

HORACE TRUMBAUER,

ARCHITECT.

The interior plans of the house and stables of Francis Bond's Willow Brook were published in *Brickbuilder* magazine in August 1907 (Vol 16, Number 8, Plate 123). Horace Trumbauer (1868–1938), noted architect, started his career with little formal training but was apprenticed early with the Hewitt brothers, George and William, a prominent Philadelphia firm. His first commissioned work, at the age of 21, was Grey Towers castle at Arcadia University. His later work included prominent projects such as the Philadelphia Museum of Art. Trumbauer's reputation grew as he worked for many industrialists of his time: Harrison, Elkins, Widener, Drexel, Gould, Duke, Clothier, Stotesbury, Dixon, and Francis Bond.

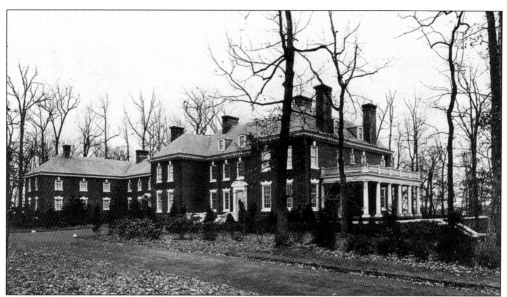

The Bonds moved into Willow Brook in 1908. The following year, *American Homes and Gardens Magazine* featured this "Banker's Georgian" on the front page of the October 1909 issue (Volume VI, Number 10). Trumbauer's original plans can be viewed at Philadelphia's Athenaeum. J. S. Cornell Company, the contractor, also deposited documents itemizing specific building materials, including red Harvard brick, Indiana limestone, copper gutters, white oak, white pine, hemlock, North Carolina yellow pine for floors and walls, white marble, Caen stone fireplaces with Dutch fireplace tiles, Doric columns, oversized windows, and Vermont slate roof.

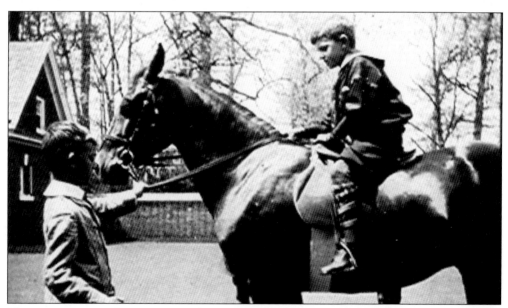

This picture was taken sometime between 1907 and 1912. Young James Bond is on the horse while his older brother, Francis, holds the reins. Trumbauer built stables for the horses and carriages, with separate apartments for the coachmen and other workers. Much recreation centered around local hunts organized by families in the area.

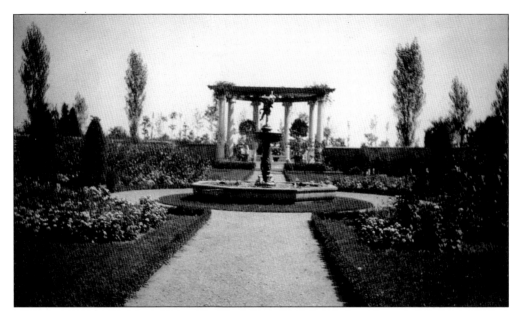

This *c.* 1909 photograph of the early walled garden shows six columns forming a semicircular pergola with wooden rafters. These Ionic columns were salvaged from the Dundas-Lippincott mansion on South Broad Street. The garden had a cruciform layout centered with a bronze cupid fountain. Hollyhocks were planted with tall cypress in the background. Grape vines are barely visible on the pergola.

At one time considered the most valuable home in Philadelphia, the Dundas-Lippincott Mansion, on the northeast corner of Broad and Walnut Streets, was built in 1839 and was called the Yellow Mansion. It was bequeathed to Mrs. Joshua Lippincott in 1865. Her son James Dundas Lippincott took over the property in 1902. A large elm tree that was planted on its southern side was a prominent landmark for many years.

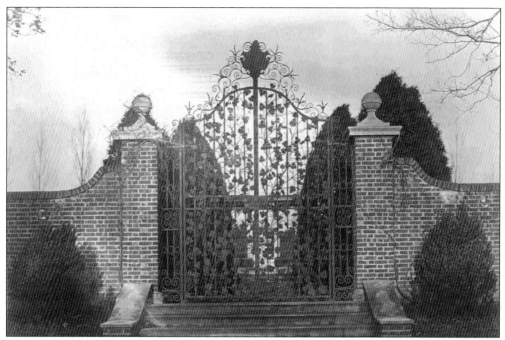

The Bonds installed an ornate garden gate, pictured here. This gate was later replaced by Roland L. Taylor, the next owner, with a second gate designed by Samuel Yellin, famous Philadelphia iron maker and artist.

James Bond attended St. Paul's School in Concord, New Hampshire, for one year after his mother's death. When his father remarried in 1914, the family relocated to England. Bond graduated from Cambridge University in economics. He returned to the United States in 1922 and worked briefly as a banker, but decided to pursue his lifelong passion of ornithology, which had been nurtured by his father. He joined the staff of the Academy of Natural Sciences of Philadelphia and worked there for more than 40 years. This picture, taken in the 1930s, shows him examining a specimen. (The Academy of Natural Sciences of Philadelphia, Ewell Sale Stewart Library.)

James Bond (left) specialized in Caribbean birds and wrote a definitive book on this subject in 1936. He married Mary Wickham in 1953, and together they continued their trips to the Caribbean. In a 1961 magazine interview, Sir Ian Fleming admitted to the world that he had "taken" the name for his secret agent 007 from the cover of Bond's *Birds of the West Indies*. This picture records the only meeting between the two men at Flemings's Jamaica home in 1964.

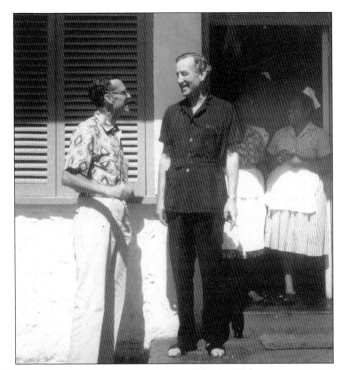

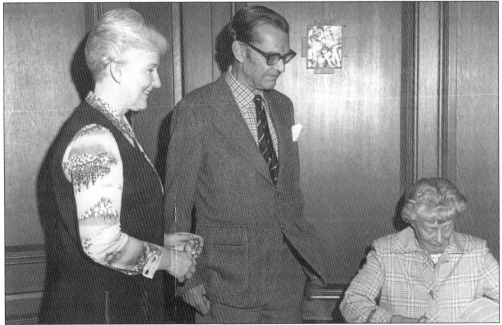

Sr. Isabelle Keiss, RSM, third president of the Gwynedd-Mercy College, met the Bonds in Assumption Hall in 1981. While researching college campus history, Marge DeSimone, admissions counselor, discovered the Bonds living in Chestnut Hill. Mary Bond is holding a copy of *Tender Courage*, Sr. Joanna Regan's book about Cathcrine McAuley. Mary, also a writer, had just published *To James Bond With Love*, describing her and her husband's travels together.

The Church of the Messiah (Episcopal) in Lower Gwynedd was founded in 1866. The Bonds, Ingersolls, and Taylors all worshipped and served here. James Bond, a vestryman, enclosed the rectory with an iron fence. Mary Bond donated an organ. Josephine Bond headed the Junior Auxiliary and gave a chancel rail. Later Roland Taylor also served as vestryman and accounting warden and donated a pulpit. Gifts from the Taylor, Ely, and Hardwick families in the 1960s helped create a terrace.

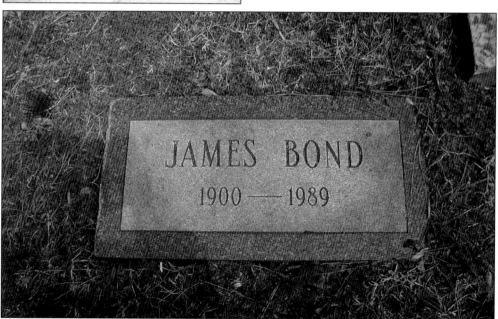

This photograph displays James Bond's grave site at Church of the Messiah. The first family member to be buried here was his sister Maggie in 1904, followed by his mother in 1913. That same year, Francis Bond had a memorial stained-glass window installed in memory of his wife. Later James's brother, Francis, was buried here. In 1997, James's wife, Mary Bond (née Wickham), was the final family member to be buried here.

Roland Leslie Taylor (1868–1946), prominent banker and businessman, purchased Willow Brook after the Bonds moved to England. Taylor married Anita May Steinmetz in 1897. Before coming to Gwynedd, Roland and his family, which included two daughters, lived in Germantown, where he was active in many Philadelphia social and philanthropic organizations. In 1914, Roland christened his new home Treweyrn.

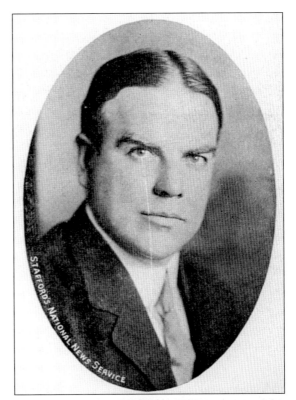

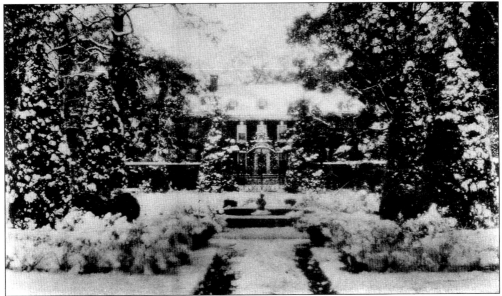

This Taylor holiday card depicts a winter scene of Treweyrn. Roland took great pleasure in this property over the years. He planted junipers, arborvitae, climbing roses, and dogwoods around the perennial garden. Outside the formal walled garden were planted 175 hybrid lilacs, mountain laurel, azaleas, and evergreens. There were 53 varieties of rhododendrons that line today's Rhododendron Drive. He also planted fruit orchards, which did not survive.

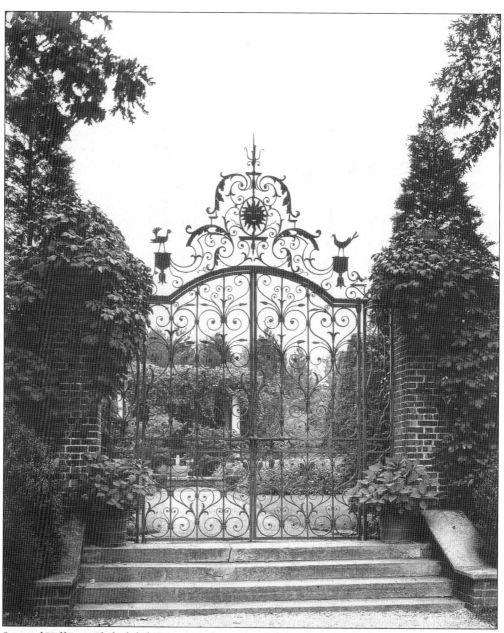

Samuel Yellin, a Philadelphia iron maker, created this gate in the 1920s. Born in Galicia, Poland, he immigrated to Philadelphia in 1906 as a master iron craftsman and established a studio at 5520–5524 Arch Street, where he employed over 200 craftsmen. Much of his work, from small boxes to large gates and fences, featured ingenious animal and floral motifs and can be seen throughout the country at schools (Bryn Mawr, Harvard, and Princeton) and churches (Washington Cathedral). His son, also an iron maker, created the cross at the Air Force Academy Chapel in Colorado Springs, Colorado. His granddaughter Clare runs a restoration business in Bryn Mawr, Pennsylvania.

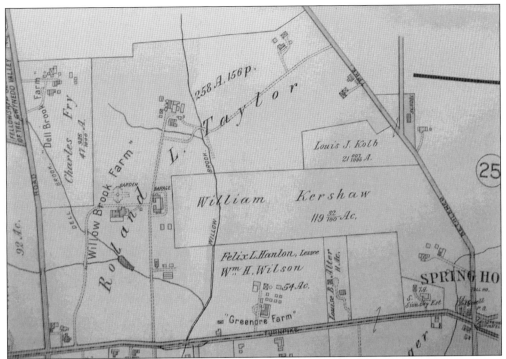

This 1916 atlas proclaims the new property owner Roland L. Taylor, although the house is still labeled Willow Brook. Greenore Farm, shown on Sumneytown Pike, was later purchased by one of Roland Taylor's daughters, Marjorie, and her husband, Gordon Alward Hardwick. Dell Brook Farm on Evans Road was later refurbished for Taylor's other daughter, Elizabeth, and her husband, William Newbold Ely Jr.

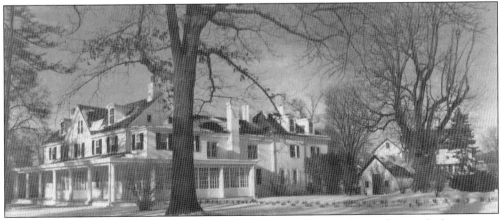

This stately home, Grenloe, faced Sumneytown Pike and was formerly known as Greenore (see the 1916 atlas). This became the home of Gordon A.Hardwick and Marjorie Hardwick (née Taylor) but was later sold to Moore Products. Consequently, the home was demolished.

Gordon Alward Hardwick, born in 1893 in Postville, Iowa, graduated from the University of Pennsylvania in 1916 and wed Marjorie Taylor in 1920. He became a vice president in the Tubize Artificial Silk Company of America. Hardwick later served on the Advisory Board of Gwynedd-Mercy Junior College. His son, Taylor Hardwick (1923–) recalls a visit by Nelson Eddy, a Philadelphia actor and friend of his grandfather. Eddy staged a one-man Halloween performance called "The Preacher and the Bear" at Treweyrn, which delighted the Taylor family.

This photograph depicts three generations of Taylor women. The portrait is of Anita May Taylor (née Steinmetz), on the left is her daughter Anita Marjorie Hardwick (née Taylor), and to the right is her daughter Anita Marjorie Hardwick. This photograph was taken during young Anita's "coming out" party in 1941.

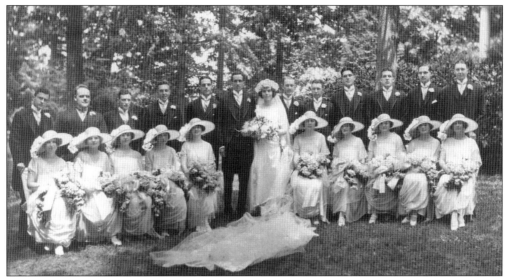

This picture is most likely on the grounds of the Taylor property during William Newbold Ely Jr.'s wedding to Elizabeth Anne Taylor in 1923. William was born in Chestnut Hill, Pennsylvania, in 1896 and attended Chestnut Hill Academy and Yale University, graduating in 1917. When they were first married, the Elys lived in the Evans House, then in the home on Evans Road that is best known as Annunciation Convent. Elizabeth Ely also owned the old Charles Danenhower home off Old Bethlehem Pike. She sold this property to the college in 1985 with the provision that she could occupy the house as long as she desired. She died in January 1986.

Ely descendants have kept in touch with the college, and in 1986, an Ely family member was named Gwynedd-Mercy. This picture shows the family visiting the campus and meeting with Sr. Isabelle Keiss in the early 1990s. Gwynedd is on the lower left.

# AN ESTATE IN GWYNEDD VALLEY

### "TREWERYN HOUSE" *Home of the late Roland L. Taylor*

#### About Two Miles from Ambler

INCLUDES:

- **34 ACRES**
  40 additional acres available, with other buildings

- Stately Georgian Residence

- Two 7-Room Brick Cottages

- Large Garage with 7 box stalls, spacious recreation room, and help's quarters

- Pond and Stream.

- Lovely English Gardens

- Greenhouses

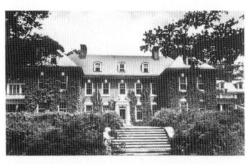

Close to the city, with exceptional transportation facilities. Chestnut Hill bus at entrance. Half hour electric train service to center of Philadelphia.

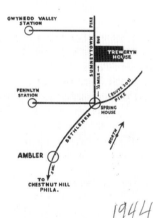

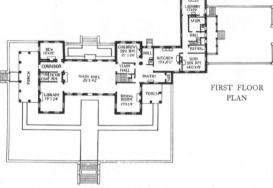

FIRST FLOOR PLAN

The magnificent Georgian residence of mellowed Williamsburg brick and limestone was designed by Horace Trumbauer. Every detail speaks of quality from the .quartered oak floors and panelling to the 14 beautiful fireplaces, silver lighting fixtures, and full sized elevator. Indirect humidified air heat, gas fired, is as modern as tomorrow. First floor plan is shown. Above are 6 master bedrooms, 4 baths, 2 guest rooms and bath, and liberal servant's quarters. The entire estate is in excellent condition and. ready for immediate occupancy.

$75,000

## Jackson-Cross
### Company

LINCOLN-LIBERTY BUILDING, PHILA., PA.      LO. 7-1505

*Suburban Offices:*
Boulevard Office—At Rising Sun Ave. DA. 4-2000
Jenkintown Office—111 York Road. MA. 5-0700

*1944*

This Jackson-Cross Company Real Estate brochure (marked incorrectly as 1944) features "Treweyrn House, home of the late Roland L. Taylor," who died in 1946. Note the Chestnut Hill bus route traveling along Sumneytown Pike at that time. Thirty-four acres and a house for only $75,000 certainly sounds like a bargain.

# *Three*

# Gwynedd-Mercy Academy and Junior College: 1947-1963

The Sisters of Mercy welcomed the first students to Gwynedd-Mercy Junior College in the fall of 1948. The college's first president and Mother General of the Sisters of Mercy, Mother Mary Bernard Graham, greeted the new students in the estate's main house, Assumption Hall, which first served as a convent for the Sisters of Mercy.

Other buildings on campus underwent extensive renovations to be transformed into educational spaces. The Gwynedd-Mercy Junior College and the academy occupied space in the former stables, now known as Byrne Hall. Several of the rooms on the second floor of Byrne Hall were assigned to the junior college. The need for space prompted the decision to expand the facilities by building an addition onto the small laundry building. This new laboratory facility was ready for use in 1950, and its opening ushered in a decade of growth for the junior college.

In addition to the educational facilities, Gwynedd-Mercy Junior College also offered students housing, transportation, and a variety of social activities. Maryllyn, the home of Edward B. Smith on Gypsy Hill Road, was purchased in 1953 and designated as student housing. The junior college also provided transportation for students in the form of two jitneys named "Patrick" and "Joseph." Students attended dances, such as the 1949 Lilac Ball, the first formal dance sponsored by the junior college. Students also took trips to Sea Isle City, New Jersey; worked on the award-winning student yearbook, the *Coelian*; participated in a variety of sports; and performed in annual plays.

The junior college's steady growth was due in part to the support of other educational institutions and agencies. Gwynedd-Mercy Junior College was affiliated with the Catholic University of America, approved by the Pennsylvania Department of Education and accredited by the Middle States Commission on Higher Education. The first decade of the junior college also saw the addition of the nursing program and the construction of Lourdes Library, the first new building to be added to the campus.

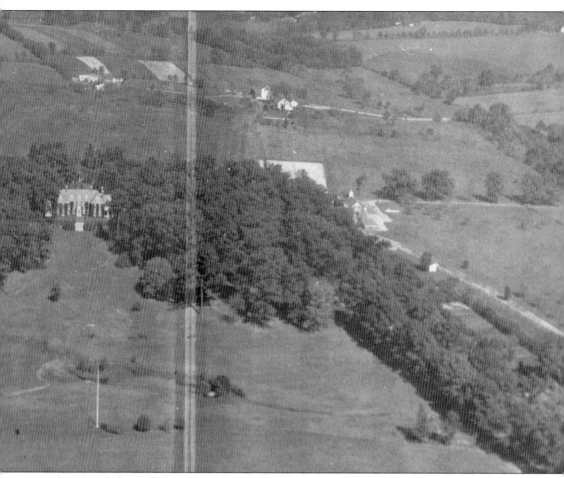

This aerial shot of the early campus clearly shows the Trumbauer mansion and stables nestled in a wooded setting and surrounded by farmland. This photograph was taken around 1954, as evidenced by the flagpole in the foreground, which stands where there had previously been several small lakes. The long driveway leading to the mansion went to the Danenhower farmhouse (now Visitation House). Note the homes to the left, later occupied by the McHugh family, and the back driveway leading to Old Bethlehem Pike.

This wooden sign was erected in 1948–1949 after the Sisters of Mercy purchased the Gwynedd property. The Evans house/St. Joseph's Convent can be seen in the distance on the right. The academy, which served both boys and girls from grades one through twelve, moved from the Broad Street and Columbia Avenue location and used Byrne Hall for classes in the early years.

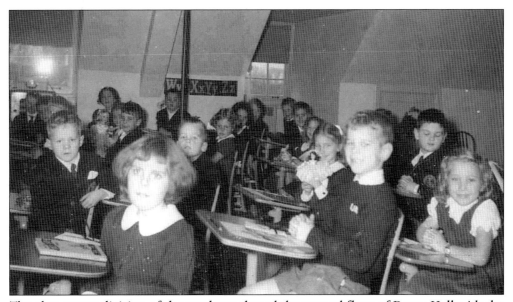

The elementary division of the academy shared the second floor of Byrne Hall with the junior college. Nineteen children, boys and girls, were enrolled in 1947. Sr. Joanna Regan taught first grade in Byrne Hall in 1948. She later became director of planning, then vice president for student affairs for the college (1975–1982). In 1978, she wrote *Tender Courage*, the biography of Catherine McAuley, in celebration of McAuley's 200th birthday.

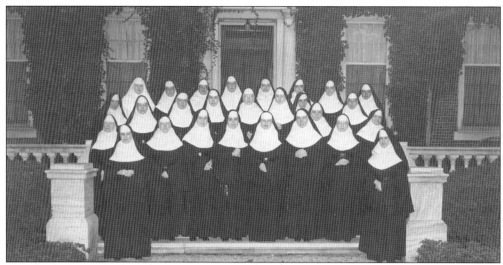

The first Mass at the Convent of Mercy was celebrated on September 24, 1947. From left to right are (first row) Sister Mary Fabian, Sister Mary Leontia, Sister Mary de Neri, Mother Gertrude Mary, Rev. Mother Mary Bernard, Mother Mary Patricia, Mother Mary Anthony, Sister Mary Euphrasia, and Sister Mary Raphael; (second row) Sister Marie Denise, Sister Anne Marie, Sister Mary Virginia, Sister Laetitia Marie, Sister Agnes Mary, Sister Mary de la Salle, Sister Mary Eileen, Sister Mary Gerard, Sister Mary Edward, and Sister Mary Matthew; (third row) Sister Mary Florita, Sister Mary Silverius, Sister Mary Jean, Sister Elizabeth Marie, Sister Mary Margaret Joseph, Sister Mary Fenton Joseph, Sister Mary Joan, and Sister Mary Berenice. This style of habit would be later described as "dressing as widows with habit for mass, choir sleeves added, a train to let down and a choir mantle. Outer dress included a long cloak, straw bonnet, and veil over the face."

A Gwynedd-Mercy Academy postcard shows the renovated stables that became Byrne Hall. Among other structural changes, large central windows replaced the old stable doors. Academy classes began on the first floor, and later elementary classes were moved to the second floor. In 1948, the first junior college classes were held on the second floor. This building was named for Mother Margaret Mary Byrne, Superior of Sisters of Mercy, Philadelphia, from 1922 through 1928, who encouraged the pursuit of higher education.

On Sunday, October 31, 1948, his Eminence, Cardinal Dennis Dougherty (left) gave Benediction of the Most Blessed Sacrament at the newly opened Gwynedd-Mercy Junior College. This ceremony was known as the "28 Roses Ceremony and Reception," with each rose representing a member of the entering class. In the early years, five courses of study were offered: secretarial, medical-secretarial, pre-laboratory technician, merchandising, and liberal arts.

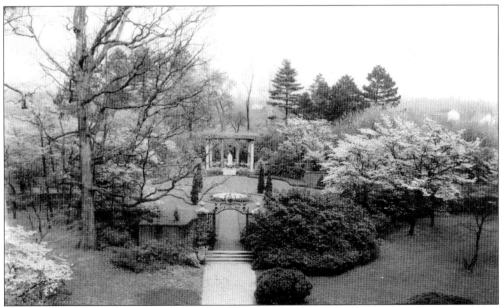

The Shrine of Our Lady of Mercy (in the Lady Garden) was donated by the High School Academy Class of 1949. This statue and garden have been a spiritual focal point of the school for many years and have seen many confirmations and graduation ceremonies. The school gets many requests to shoot wedding photographs in the garden because it is so picturesque.

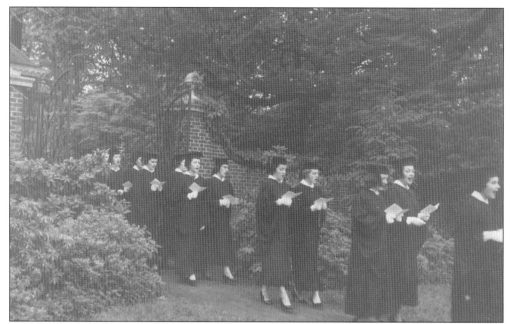

Early graduates (around the 1950s) processed into the Lady Garden through the stately Yellin Gate. Note the full rhododendron bushes that grace the entryway, courtesy of the Taylor family. These bushes still thrive today in the Lady Garden and across campus.

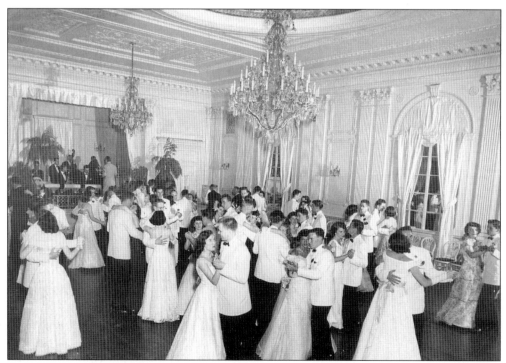

The first formal dance sponsored by Gwynedd-Mercy Junior College, the Lilac Ball, was held at the Barclay Hotel on June 3, 1949. Students and their dates danced the night away to the Leo Zollo Orchestra.

In 1949, the First Lawn Fete was organized to celebrate the end of the first year of Gwynedd-Mercy Junior College. Students entertained families and friends with booths set up to sell various items, including children's clothing and handcrafted goods. Other booths contained a tombola, fish pond, and other games of chance. A giant croquet set was made available, and pony rides were offered. Such fun events continue even today in the form of FallFest.

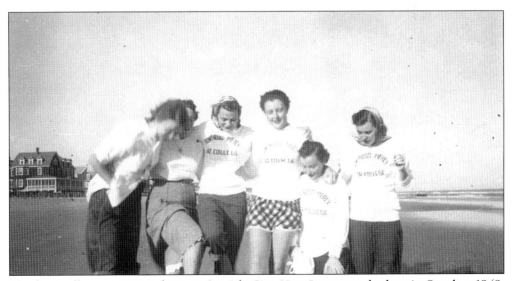

The first college-sponsored trip to Sea Isle City, New Jersey, took place in October 1949. These six students, most of whom proudly sport their Gwynedd-Mercy Junior College shirts, clearly enjoyed their day at the shore.

In 1949, an extension was added to the small laundry building on the estate. This became the first science building. The small laundry section served as a classroom and the extension as a science laboratory for both the academy and the junior college. Two later additions were built in 1959 and 1973.

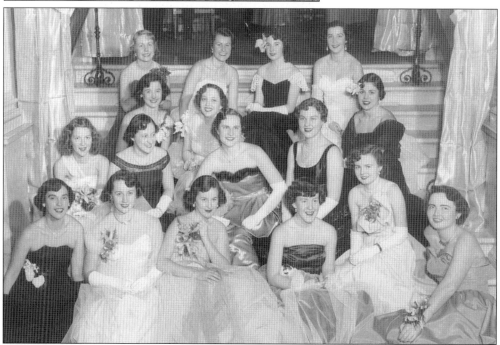

The 1950 senior ball was held on February 3 at the Barclay Hotel. Chuck Gordon and his orchestra provided the entertainment. This photograph captures a number of students elegantly dressed and prepared for a delightful evening.

The home of Elizabeth Ely (née Taylor) was purchased in 1951 and named Our Lady of Mercy Convent; it is today referred to as Annunciation Hall. The barn attached to the property was converted in 1981 to house the Allied Health Department.

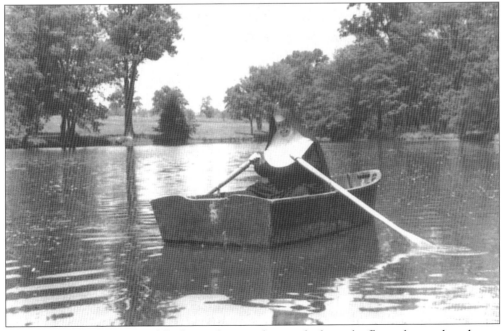

In 1953, Sr. Mary Martin paddled a rowboat in the pond where the flagpole stands today on campus. This is perhaps one of the most memorable pictures of early college history.

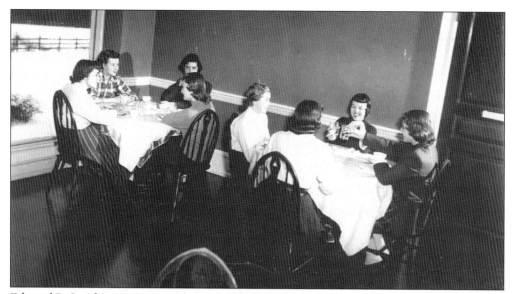

Edward B. Smith's summer residence on Gypsy Hill Road was purchased in 1953, renamed Maryllyn, and became the first student dormitory. Smith was educated at William Penn Charter School and the University of Pennsylvania. Most notably, Smith started the Edward B. Smith and Company banking firm (which later became Smith-Barney and most recently part of Citicorp) in 1892 with Francis E. Bond. The school owned this property until the mid-1960s. This photograph depicts the "freshman corner" of the dining room.

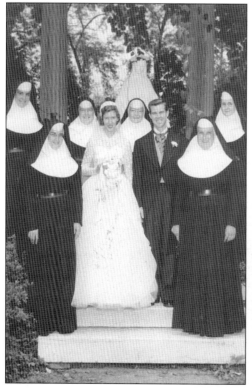

The engagement of Maria Lutz, a gym instructor, to James McHugh was announced in March 1953. The McHughs were married in the Lady Garden, and Maria continued her career in the physical education department until her retirement a few years ago. A true Gwynedd-Mercy family, her husband taught at the academy, and their children were involved in the summer camp program for many years.

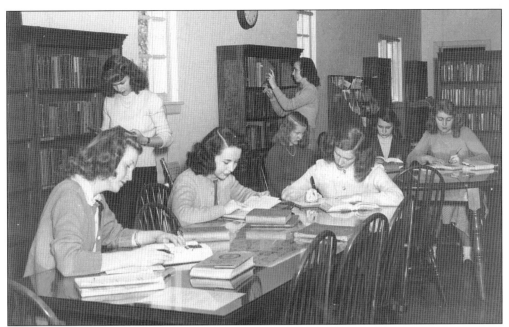

As this *c.* 1955 photograph shows, the library was originally housed in Byrne Hall. Books and wooden bookcases came from the Broad and Columbia Library. Old bookplates can still be seen occasionally in Gwynedd-Mercy College's current holdings. The wooden bookcases can still be seen in the Fireside Room and the Archives of Lourdes Library.

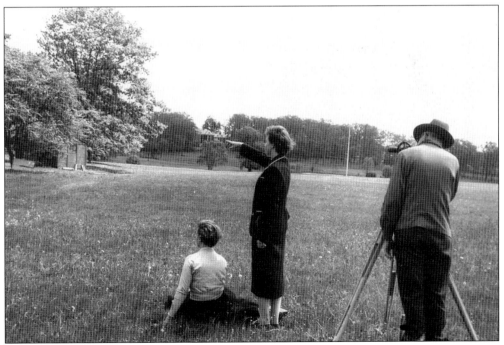

A land survey was conducted to identify the optimal location for the new Academy High School complex. Note Assumption Hall and the flagpole in the distance. This picture was taken after the pond was drained in 1954.

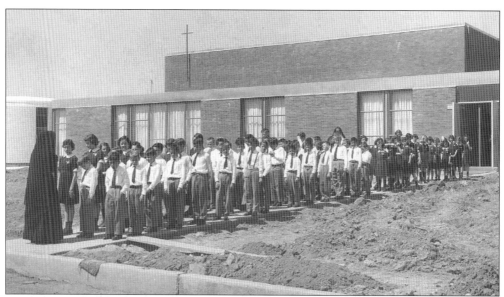

In April 1955, the new academy building was finished. Some elementary and secondary classes were moved from the ground floor in Byrne Hall. However, a boy's division (grades one through eight) continued to share Byrne Hall with the junior college. In 1983, the elementary division moved to the former Springhouse Elementary School on Norristown Road.

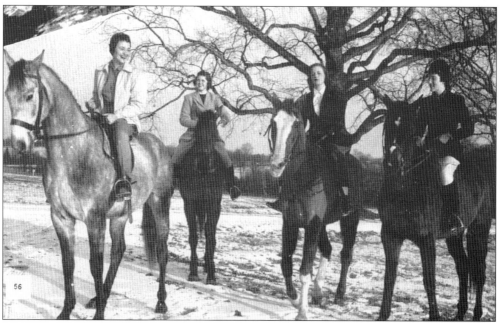

Horseback riding was quite popular with the students of the junior college. In fact, the school had its own horses, Rogue and Star, according to the 1954 yearbook. Pony Express, a third horse, is highlighted in the 1955 yearbook. This 1957 yearbook photograph shows four unidentified riders seated on their horses. The next year, documentation shows that a student identified as P. McGinn was residing at Maryllyn and boarding horses next door.

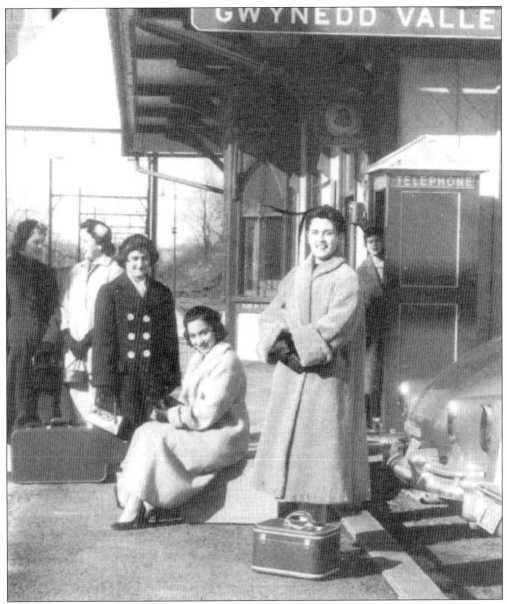

The Gwynedd Valley train station is pictured in the 1955 and 1958 yearbooks and also in a later college calendar. The station was an important transportation link for students, some of whom had started to live on campus.

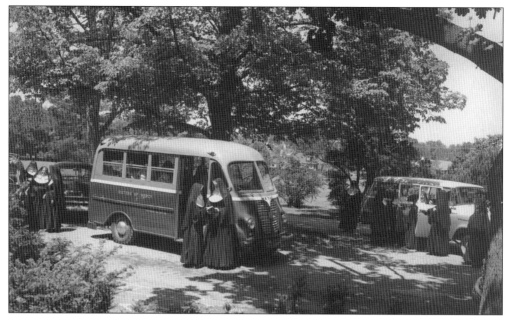

Gwynedd-Mercy Junior College's first green jitney bus was "Patrick," an International Harvester Metro. Sister Mary Jean and Sr. Mary Colman took turns transporting students around the campus. Later, a second bus named "Joseph" was added to the fleet. Other modes of transportation included a 1951 Desoto that resided at Maryllyn and a black Mercury station wagon donated by Herman Ball.

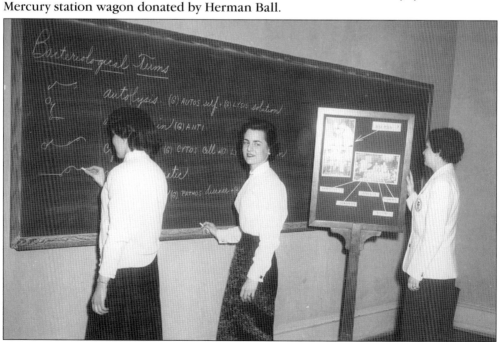

Classical nomenclature tied in with studies in bacteriology for medical-secretarial students at Gwynedd-Mercy Junior College. Mary Ann Wittner, Patricia Byrne, and Margaret Anne Smith are seen here in one of their classes. This picture was published in the *Catholic Standard and Times* on April 1, 1955.

Early in the history of the junior college, plays became an annual event. *The Dance of Death*, a drama in five episodes, was presented in December 1955, with boys from LaSalle College playing the male roles. More than one romance began on the theater stage, and several marriages resulted, according to alumni records.

Plays were not the only cultural event staged at Gwynedd-Mercy Junior College. In fact, the staff and students were able to enjoy visiting acts, including a dance troupe from Mercy College in Detroit, pictured here during a stirring performance.

The outdoor pool opened in 1957 for use by the academy, the summer camp, and the junior college. The summer camp, which celebrated its 50th anniversary in 2005, offered a healthy environment for many inner-city children.

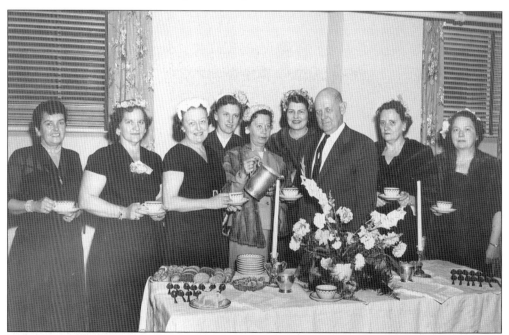

Parents were very much involved with the success of the junior college. This Parents' Tea in 1958 was probably held in the Byrne Hall basement, as evidenced by the pipes running along the ceiling. The cafeteria was also located in the basement at this time. There were also Mothers' Clubs, card parties, and fashion shows to raise funds for the school.

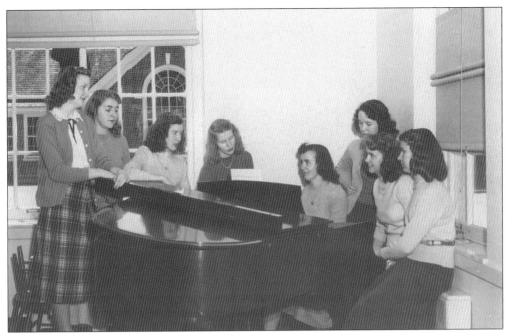

Byrne Hall served many roles over the years, but it always remained a central location where students could come together. Whether they were attending class, studying together, or gathering around the piano for a song, students forged many friendships in the former stable.

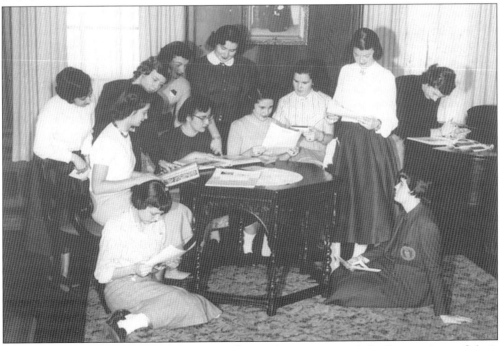

The yearbook has always been a means for students to record the happenings of their school year and preserve their memories. These early yearbook staff members took their jobs very seriously, meeting to examine their hard work.

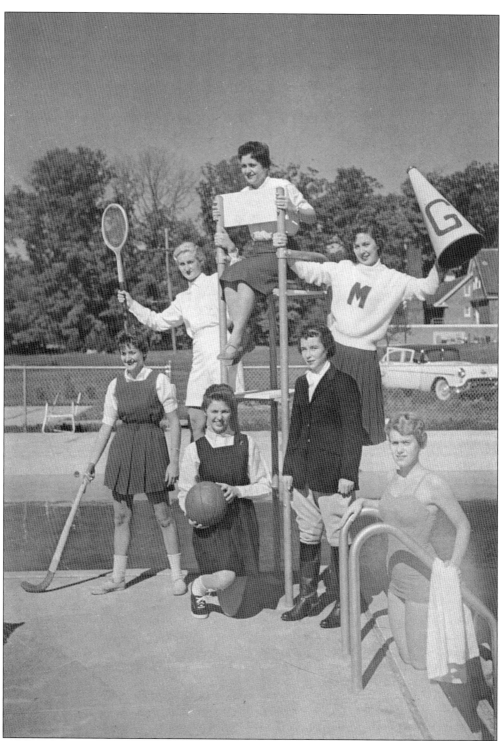

Clearly, athletics were popular at Gwynedd-Mercy Junior College. Sports included swimming, tennis, field hockey, volleyball, cheerleading, and riding. By the end of the 1950s, both a college song and a college flag had been created.

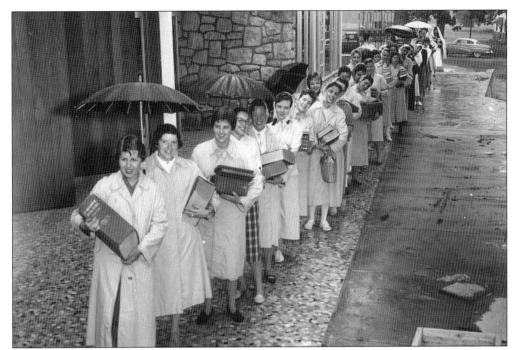

A new library was dedicated on September 24, 1959, and named for Our Lady of Lourdes. Despite the rainy weather, a human chain was formed by helpful students to carry books from Byrne Hall to the new Lourdes Library.

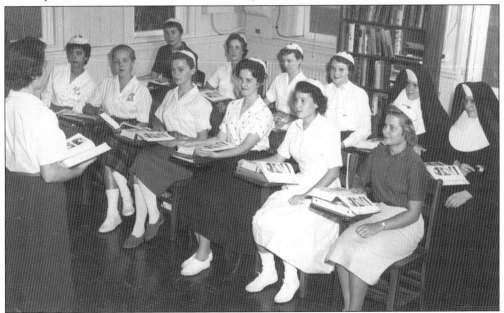

As evidenced by the beanies, this photograph shows a freshman nursing class meeting in Byrne Hall around 1959. When the associate's degree in nursing was introduced, it was the first of its kind offered at a Catholic junior college in the United States. By the end of the 1950s, the junior college was firmly established and ready for the next decade and period of growth.

This 1959 photograph depicts Carolyn Hayes (seated), a nursing student at Gwynedd-Mercy Junior College (the "youngest school of nursing in the area") with Patricia Reese (standing), a student at the "oldest nursing school in the area –Woman's Hospital." They are posing with a bust of Florence Nightingale, who established the first modern school of nursing in London in 1860.

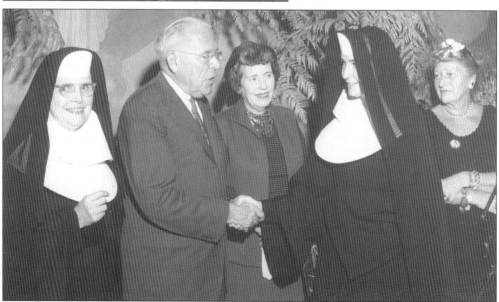

Here Gov. David Lawrence is being greeted by Sister Mary Joan, academic dean of Gwynedd-Mercy Junior College at the Motherhouse in Merion Station. Looking on, from left to right, are Mother Mary Bernard Graham, first president of Gwynedd-Mercy Junior College; Mrs. Lawrence; and Mrs. Matthew McCloskey. Mother Mary Bernard Graham retired as president of the junior college in 1959, and Sr. Mary Gregory Campbell, RSM, Ph.D., was named the second president.

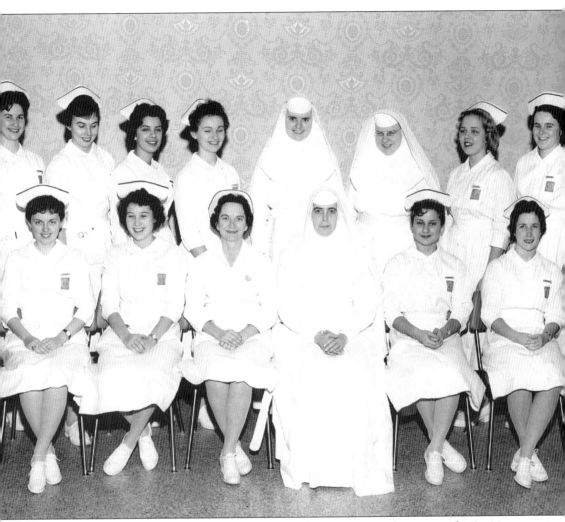

This is the first graduating class of associate degree nursing students in 1961. Sr. Mary Fenton Joseph Fitzpatrick is seated in the front row.

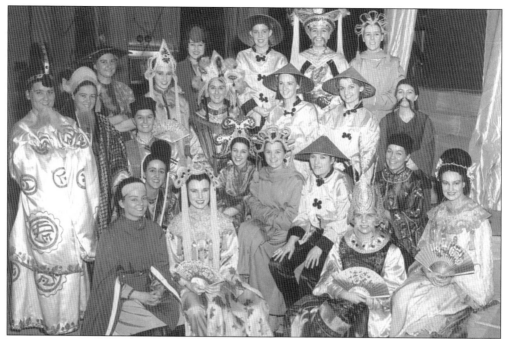

The 1962 yearbook recorded the lavish theatrical production of *The Lute Song* with cast members M. Craig, C. Doyle, C. Walsh, L. Mina, S. Wolff, M. Clark, M. Murphy, P. Carr, M. Burdo, A. Trotter, C. Rubino, C. McGuire, S. Eyth, J. Darzbach, P. Gibbons, P. McCall, M. Garvin, S. Rivardo, H. McNeill, C. Sauer, P. Mardinly, and K. Hutchens. Sister Jean Marie and Sister Marian Rita assisted behind the curtains.

Members of Sigma Phi Sigma, the national Sisters of Mercy honor society dedicated to the ideals of fidelity, scholarship, and service, received their stoles at Honors Convocation in 1962. From left to right are (first row) K. Hutchens and G. Kosich; (second row) C. Ogburn, L. Regli, T. Iovacchina, and Sister Marie Denise.

According to the 1963 yearbook, the red and gold "Kangaroo Court" was held in the Byrne Hall quadrangle. "Bagged" seniors brought capped freshmen "Justice." Hopefully, a good time was had by all.

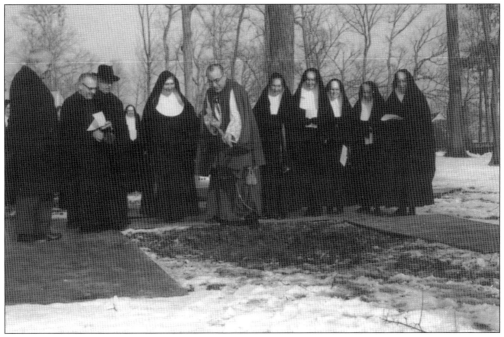

In 1963, Gwynedd-Mercy Junior College moved forward on the construction of a new academic center. On January 7, 1963, Msgr. John Graham ceremonially broke ground as several Sisters of Mercy and friends of the junior college looked on.

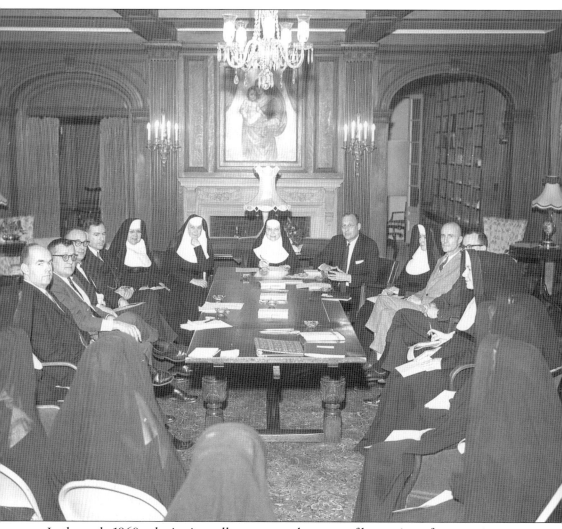

In the early 1960s, the junior college was on the verge of becoming a four-year institution and many plans were being considered. This photograph captures a meeting of the Development Committee in Assumption Hall on May 28, 1963. From left to right are Frank T. O'Neill, Hubert J. Horan III, Edward C. Driscoll Jr., Frank R. Donahue Jr., Sister Mary Joan of Arc, Sr. Mary Gregory Campbell (Gwynedd-Mercy Junior College's second president), Sr. Mary Bernard Graham (Gwynedd-Mercy Junior College's first president), Stanley B. Kitzelman, Sister Mary Joan, Guy F. Hopkins, Gordon Cavanaugh, and Sister Mary Anthony.

# *Four*

# GWYNEDD-MERCY COLLEGE: 1964-1971

In May 1963, Gwynedd-Mercy Junior College received approval to award baccalaureate degrees and changed its name to Gwynedd-Mercy College to reflect this new status. This paved the way for many changes to the campus, including the construction of several new buildings. The McAuley Academic and Cultural Center was completed and dedicated in 1964 and was soon followed by the opening of Loyola Hall, the first on-campus dormitory, and the Waldron Student Center in 1965.

Sr. Mary Gregory Campbell, who served as the second president of the college from 1959 to 1971, oversaw not only the physical growth of the campus, but also the expansion of the baccalaureate programs during the 1960s. Sister Mary Gregory had previously served as academic dean and was one of the college's chief administrators. In 1967, nursing and business education were added to the baccalaureate curriculum, and two years later, 208 students of the 20th-anniversary class of Gwynedd-Mercy College graduated. Sister Mary Gregory also announced that men would be formally welcomed as students in the fall of 1966.

During this time period, the college conducted several self-studies to produce favorable accreditation, expanded access to grants and loans, and continued to recruit the best faculty and staff possible. The year 1970 was a record-setting year for the institution; the dormitories were filled to capacity, and the fall enrollment was the largest ever, including 257 freshman. By the time Sister Mary Gregory's presidency ended in 1971, more than 3,500 students had graduated from the college.

THE BOARD OF DIRECTORS
AND
THE ADMINISTRATION
OF

## GWYNEDD-MERCY JUNIOR COLLEGE

ANNOUNCE
THE COLLEGE'S CHANGE OF STATUS
TO AN ACCREDITED FOUR-YEAR INSTITUTION
WITH POWER TO GRANT
THE BACCALAUREATE DEGREE IN ARTS AND SCIENCE
AND ITS CHANGE OF TITLE TO

## GWYNEDD-MERCY COLLEGE.

THE COLLEGE WILL CONTINUE TO GRANT
THE ASSOCIATE DEGREE
IN NURSING, MEDICAL SECRETARIAL, AND SECRETARIAL SCIENCE.

As this announcement clearly states, the college was now able to grant baccalaureate degrees but maintained several associate's degree programs. The college was renamed Gwynedd-Mercy College at this time.

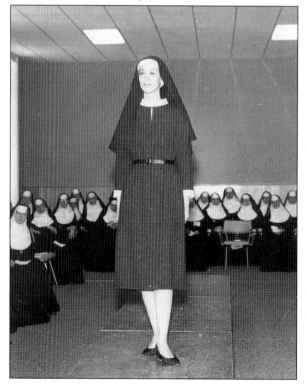

New habits were being considered by the Sisters of Mercy, and several designs were contemplated. This Sybil Connolly design was modeled for the sisters in 1965, but was considered "too stylish." Connolly was a popular Irish designer.

A college shield was created to reflect the institution's new status. The shield of the Sisters of Mercy was retained on the left; the upper right field contains the dragon of Wales in red, symbolizing Gwynedd. In the right center are three balls on a red background taken from William Penn's coat-of-arms, while in the lower part is the lamp of learning, in gold. Below the shield is a red banner proclaiming the motto *Veritas et Misericordia*, Latin for "Truth and Mercy."

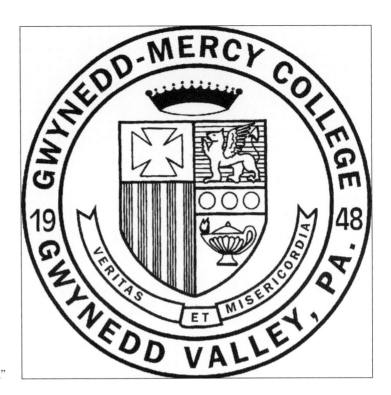

The First Annual Gwynedd-Mercy Gala Pops Concert was held at the Academy of Music on February 29, 1964. Andre Kostelanetz conducted the Philadelphia Orchestra, and the concert was followed by dinner and dancing at the Sheraton with Al Raymond and his Orchestra. This event was envisioned and executed by Mary Catherine Maguire, class of 1963.

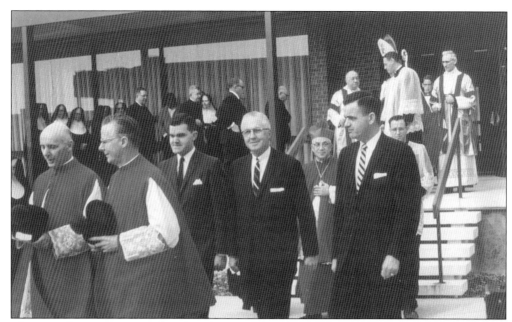

The McAuley Academic and Cultural Center, a complex of five buildings and a courtyard with a Cross of Christ as the center feature, was dedicated on April 12, 1964, by Cardinal John Krol, Fr. Patrick McCabe, and Fr. Francis Revak. Msgr. Charles B. Mynaugh gave the keynote address, and Thomas Schubert and William Schubert, board advisors, attended. Philadelphia Mayor James Tate and his daughter Anne Marie were honored guests of the day.

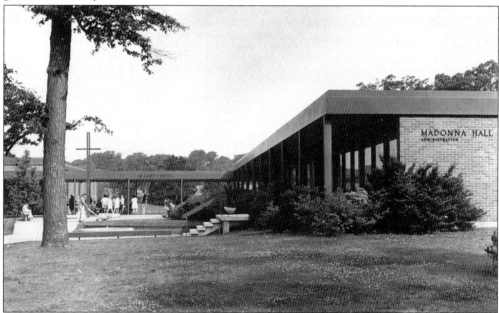

Each building was given a specific name. They included Fatima, Mercy, Madonna, and St. Bernard Halls, and Julia Ball Auditorium (named for a board advisor). In 1988, Madonna Hall was renamed Campbell Hall to honor Sr. Mary Gregory Campbell, who served the college from 1948 to 1986 as faculty member, academic dean, and president.

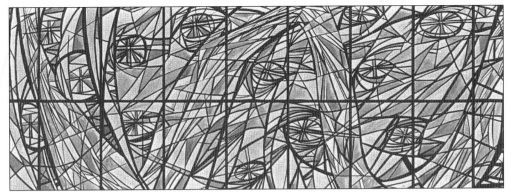

Charles L. Madden, graduate of the Philadelphia College of Art (now University of the Arts), was commissioned in 1963 to design the chapel window called *The Works of the Sister of Mercy*, his first commissioned work in Philadelphia. A reciprocal form symbolizing the grace coming from God dominates the work. Around this form are seven white-centered crosses denoting the Spiritual Works of Mercy and seven red-centered crosses denoting the Corporal Works of Mercy.

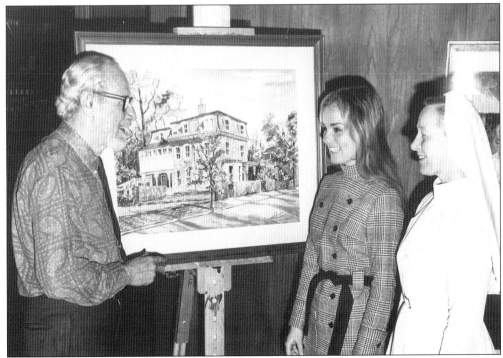

Odien K. Johnston, a lecturer in art, painted prolifically during his time here and produced many lovely pieces of art. At right is junior Michele Mohnac and Sister Bernard Mary.

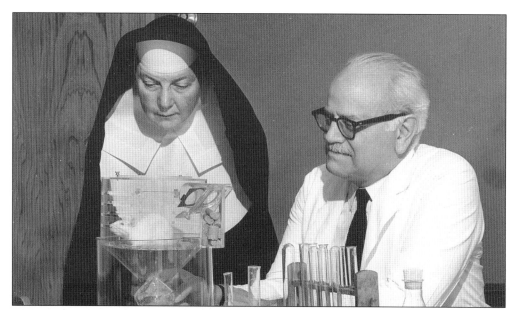

Sr. Mary Gregory Campbell was reaching out to the research departments of nearby industrial companies in the early 1960s. Dr. Gustav Martin, a graduate of the University of Washington, University of Chicago Medical School, and Johns Hopkins University, was director of research at the William H. Rorer pharmaceutical firm in Fort Washington, Pennsylvania. His private interest was in alcohol dependency, and he collaborated with Gwynedd-Mercy College until his death in 1967. The college has since renamed the original science building Gustav Martin Hall to honor this man and the groundbreaking work he did with students.

Patricia Martin, wife of Gustav Martin, served on the President's Council and received an honorary degree from the college in 1972. Following the death of her husband, she bequeathed his personal library to Gwynedd-Mercy College. Through her donations, the science department received a grant that allowed for the expansion of its facilities. (Courtesy of Curtis Publishing Company.)

Sr. Mary Gregory Campbell (right) posed next to movie star Rosalind Russell during the shooting of the film *Trouble with Angels*. This film also starred Hayley Mills, Gypsy Rose Lee, Ida Lupino, and Mary Wickes, whose sister was a Sister of Mercy. The external shots of the movie were filmed at St. Mary's Villa in Ambler in 1965.

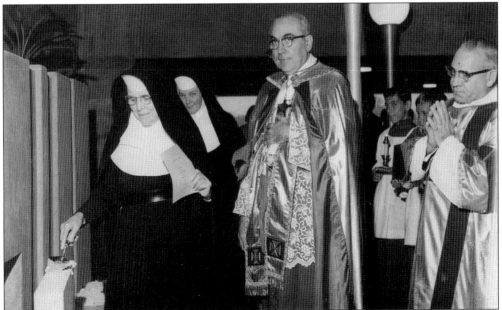

Ground was broken for the Waldron Student Center and the first dormitory in July 1964. To raise funds for construction, the school held a "Chocolate Drive." Shown here laying the cornerstone at the August 22, 1965, dedication ceremony are, from left to right, Mother Mary Bernard Graham, Sr. Mary Gregory Campbell, Bishop John Graham, and Fr. Solomon Mazieka.

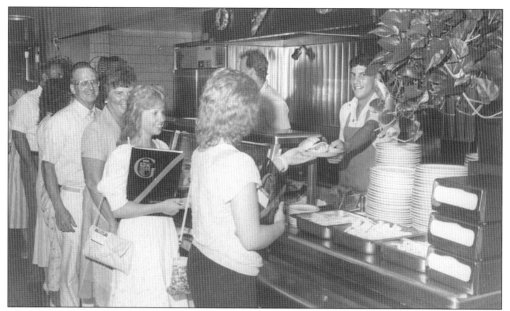

The new cafeteria in the Waldron Student Center was a very popular place when it was opened in the fall semester of 1965. Students, faculty, and staff all dined there on a regular basis.

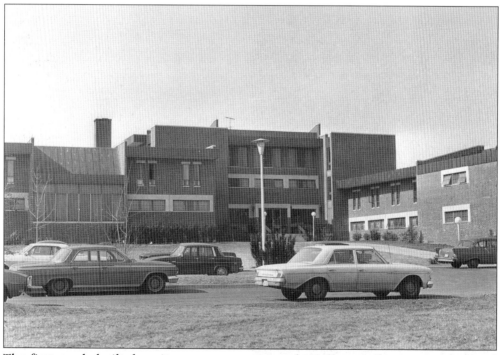

The first newly built dormitory on campus, Loyola Hall, was also constructed and dedicated alongside the Waldron Student Center. Loyola Hall opened in September 1965 to 150 students and continues to house Gwynedd-Mercy students today.

Another popular gathering place on campus was (and remains) the Lourdes Library at the heart of the campus. Here John H. Mulholland, an assistant librarian, helps a student check out books.

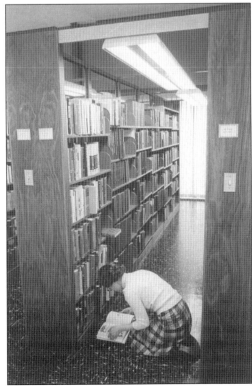

Ever studious, the students of Gwynedd-Mercy College prowled the stacks for information to enhance their papers and reports. This student intently scans one of the many science books available for research.

This early photograph of students relaxing in a room in Loyola Hall captures the flavor of the 1960s and the camaraderie of students. Note the shag rugs and 7-UP bottle design. Maryllyn was still being used as off-campus housing with a jitney bus providing transportation.

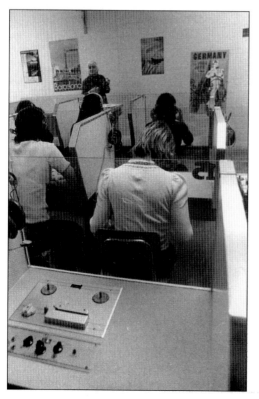

Shown here is a language laboratory featuring the latest equipment for that time, with multiple channels for different course offerings. By the late 1960s, the following programs were offered leading to the baccalaureate degree: biology, business education, elementary education, English, French, history, Latin, mathematics, medical technology and nursing.

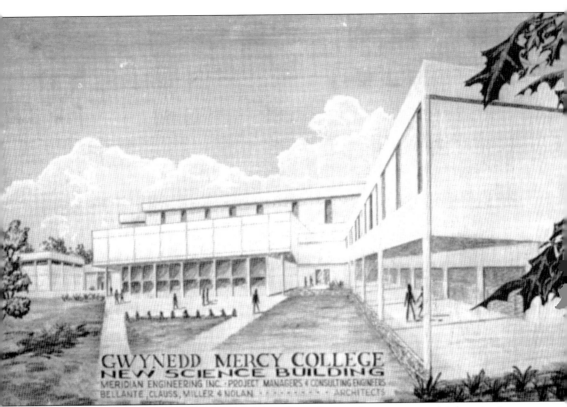

GWYNEDD MERCY COLLEGE
NEW SCIENCE BUILDING
MERIDIAN ENGINEERING INC. · PROJECT MANAGERS & CONSULTING ENGINEERS
BELLANTE, CLAUSS, MILLER & NOLAN · · · · · · · · · · ARCHITECTS

During the mid-1960s, the greatest need was for science classrooms and laboratories. Gwynedd-Mercy College was affiliated with several area hospitals at this time: Bryn Mawr, Fitzgerald-Mercy, Misericordia, North Penn, and Eugenia. As this schematic shows, a science building was planned around 1967 by the architectural firm of Bellante, Clauss, Miller and Nolan but was not built at this time.

Sr. Mary John Aloyse, the director of admissions, interviews prospective students in this 1968 photograph. Personal attention and active involvement with the students is a hallmark of Gwynedd-Mercy College.

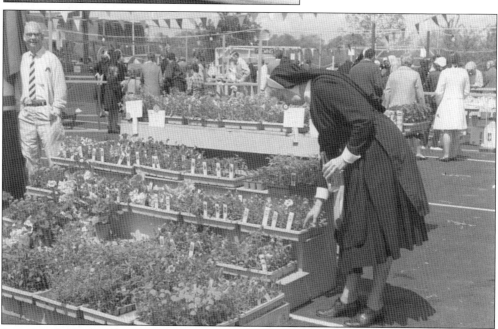

It was a chilly day for the May Fair in 1969, but the festivities were held as planned. Regardless, the crowds enjoyed the day. Here one sister inspects the offerings at the flower stand. The May Fair also included a "groceries wheel" booth, a boutique, and a visit from Francis H. Trainer, a board member, in his antique flivver automobile.

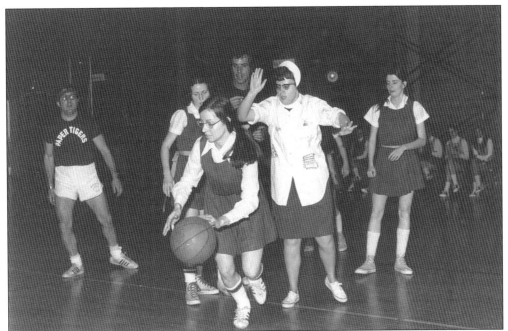

The Sisters of Mercy were not only involved in the academic affairs of the college, they also participated in the co-curricular activities. Here a sister referees a basketball game, possibly between faculty and students on March 5, 1970.

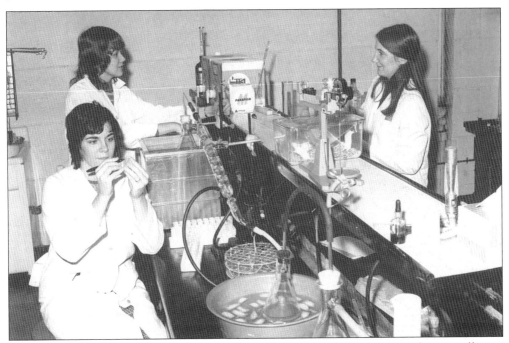

Science programs were alive and well as the college expanded in both student enrollment and course offerings. Shown are three students in a biology laboratory completing their assignments. The laboratory is fully equipped with a distilling unit, scales, test tubes, and white mice in a cage.

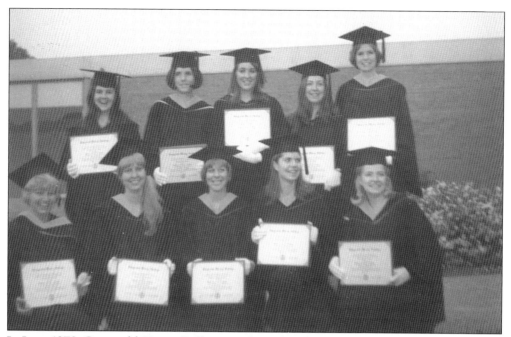

In June 1970, Gwynedd-Mercy College graduated its first baccalaureate class in nursing. From left to right are (first row) Sue Scott, Geraldine Stepsus, Dolores Gillan, Deborah Thompson, and Julia O'Leary; (second row) Sue Foley, Dorothy Savryk, Kathy O'Brien, Linda Baker, and Kathleen O'Malley.

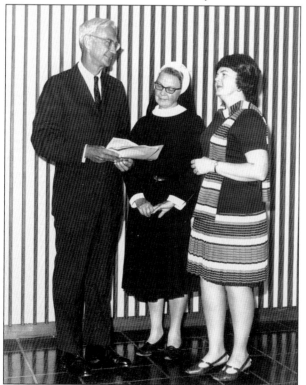

The annual faculty workshop on August 27 and 28, 1970, focused on "Goals for the 70s." Pictured here are Dr. William K. Shelden (left), educational consultant and former executive director of the National Commission on Accreditation; Sister Mary Gregory (center); and Dr. Anne Kaler (right). As Sr. Mary Gregory Campbell prepared to retire in 1971, Gwynedd-Mercy College looked to the next decade.

# *Five*

# THE KEISS YEARS: 1971-1993

Sr. Isabelle Keiss, the college's third president, was appointed in 1971. Like her predecessors, she oversaw much growth and development during her tenure. Over the course of her presidency, several new buildings were constructed, including the Connelly Faculty Center and the Griffin Complex. Two other notable projects, an addition to the Lourdes Library and the campus bell tower, were also undertaken during Sister Isabelle's time.

The physical growth mirrored the growth in student population and curriculum. The college opened a second campus in Edmonda Hall in Delaware County, adjacent to Fitzgerald Mercy Hospital. New programs in computer science, business, and health careers were initiated, and graduate programs in nursing and education were launched, continuing the college's commitment to the Sisters of Mercy tradition of service to society.

Many other changes occurred during Sister Isabelle's tenure. The school celebrated its 25th anniversary in 1973. A five-year master plan highlighted initiatives providing opportunities for full-time working adults by offering evening, weekend, and summer classes. Cooperative agreements were initiated with other organizations to provide a wider range of educational opportunities.

In the early 1980s, Frank Genuardi donated a new pavilion next to the outdoor pool, which is still heavily used today. Land was purchased and sold as the school juggled the needs of an expanding institution and the restrictions of its budget. Sister Isabelle lobbied hard for governmental grants during this period, and the college was successful in initiating both Upward Bound and the Health Careers Opportunity Program (HCOP).

The college celebrated its 40th anniversary in 1988, and as the school entered the 1990s, more changes occurred. An artist-in-residence program was started; fund-raising reached new levels; and alumni were returning to campus in record numbers. When Sister Isabelle announced her retirement in 1993, the school threw a gala farewell dinner in the Griffin Complex. The memory of her legacy lives on with the Sister Isabelle Keiss Scholarship Endowment Fund established in her name and through the Sister Isabelle Keiss Center for Health and Science.

Gwynedd-Mercy College welcomed Sr. Isabelle Keiss (right) as the third president in 1971. Sister Isabelle was a graduate of West Catholic Girls High School and joined the Sisters of Mercy in 1952. She received a bachelors of arts in 1960 from Villanova University and taught in Pennsylvania and Virginia before pursuing her master's degree at Catholic University of America. She went on to earn a doctorate in English at the University of Notre Dame. She is pictured here with her predecessor Sr. Mary Gregory Campbell in the modern habit that had been adopted.

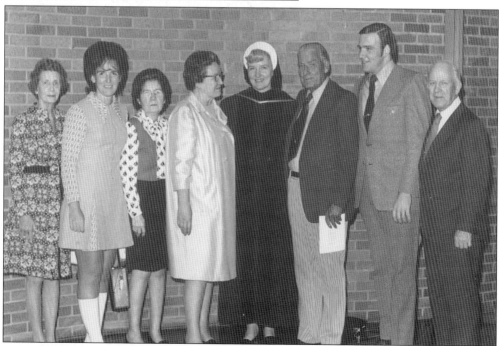

Sr. Isabelle Keiss's inauguration took place on April 16, 1972. Members of the Keiss family came to Gwynedd-Mercy College to celebrate with the new president. Walter and Sarah Boyle Keiss are on either side of President Keiss.

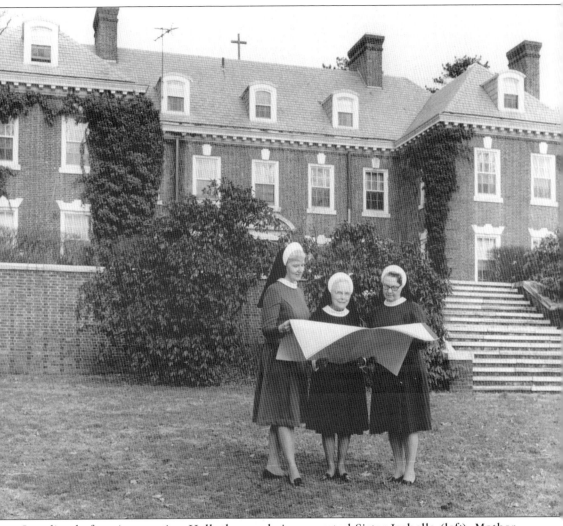

Standing before Assumption Hall, the newly inaugurated Sister Isabelle (left), Mother Mary Bernard Graham (center), and Sr. Mary Gregory Campbell (right), the present and past presidents of Gwynedd-Mercy Junior College/Gwynedd-Mercy College, review blueprints for the next campus initiative. This photograph was taken in March 1973.

This photograph displays the second extension to the Bond Laundry/Science Building (now Gustav Martin Hall). This new construction provided much-needed additional space of 3,000 square feet. This structure included a mechanical room, storage space, a large shared faculty office, a faculty lavatory, and two biology laboratories.

Murray Levin, the first male resident student in 1972, lived on campus in exchange for his services as bus driver and worker for the mailroom, security, and maintenance. He is also credited for proposing a child-care center; Hobbit House started the next year. Tom Bodziak (shown here) is credited as the first male graduate in May 1974, since Levin did not graduate until August 1974.

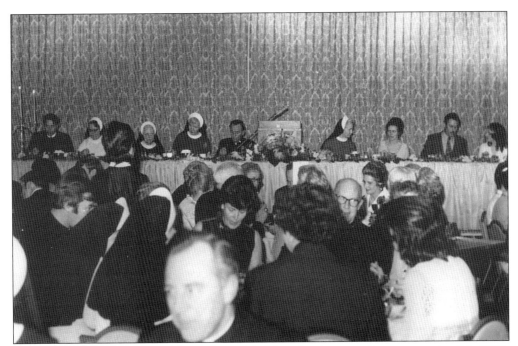

Gwynedd-Mercy College celebrated its 25th Silver Anniversary Banquet on April 1, 1973, at the Holiday Inn Regency Ballroom on City Line Avenue in Philadelphia. Louis Grant provided the music as attendees danced the night away.

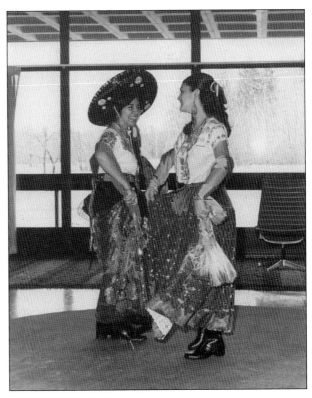

Gloria Jimenez (left) and Fernanda Hoyo, both students from Mexico, practice a native dance that they performed at the Fifth Annual International Night on April 5, 1973. The foreign language department of Gwynedd-Mercy College sponsored the event to demonstrate the music, poetry, dances, and films of various countries. International Night continues to be a yearly event at the college today.

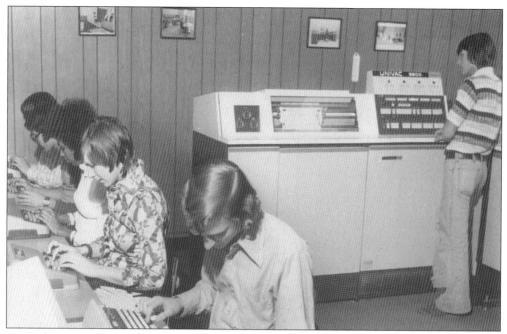

Several pictures taken in spring 1974 record specific equipment used in the school's curriculum. In 1974, the college entered into an agreement with the Maxwell School of Computer Science. This picture shows students learning the fundamentals of an early UNIVAC computer.

Students in the various Allied Health programs were doing clinical work in many of Gwynedd-Mercy College's affiliated hospitals. This picture shows students using laboratory equipment as part of their training.

In 1974, as shown by the sign, Gwynedd-Mercy Academy for Boys was still utilizing some of the Byrne Hall facilities that housed the early academy and junior college. They did not have their own home until the early 1980s, when the academy purchased Springhouse Elementary School on Norristown Road and moved to its new location.

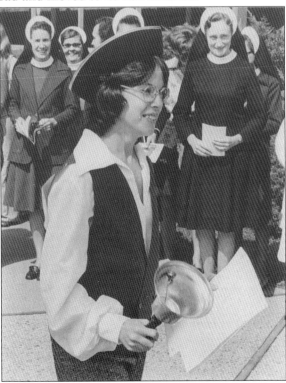

Gwynedd-Mercy College's celebration of the United States Bicentennial opened on September 22, 1976, with a Patriots' Muster and the reading of a proclamation. Mary Kirby served as crier with bell in hand and three-cornered hat. Also pictured are, from left to right, Sister Marie Suzanne, Sr. Joan Hasson, and Sr. Mary Colman. Other events were held throughout the year celebrating "liberty, freedom, and justice for all."

The John Evans Bicentennial Committee announced a "Colonial Feast & Frolic Ball" to be held on February 28, 1976, in Regina Coeli Auditorium at Gwynedd-Mercy Academy next to the college campus. Tickets were $17.76, and colonial costumes were encouraged. Entertainment included the Mostovoy Strings and Bucky Walters as a "Revolutionary Soldier." Twenty-five midshipmen were invited from the U.S. Naval Academy.

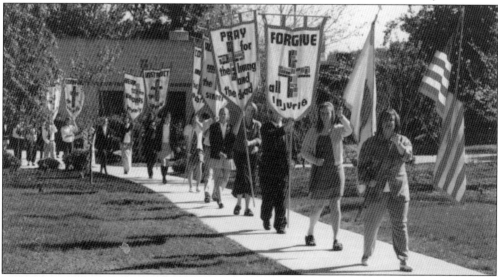

This procession features the Mercy Flags, an important part of many college and Sisters of Mercy ceremonies. These flags denote the Corporal Works of Mercy: to feed the hungry; to give drink to the thirsty; to clothe the naked; to shelter the homeless; to visit the sick; to ransom the imprisoned; and to bury the dead, and the Spiritual Works of Mercy: to instruct the ignorant; to counsel the doubtful; to admonish sinners; to bear wrongs patiently; to forgive offences willingly; to comfort the afflicted; and to pray for the living and the dead.

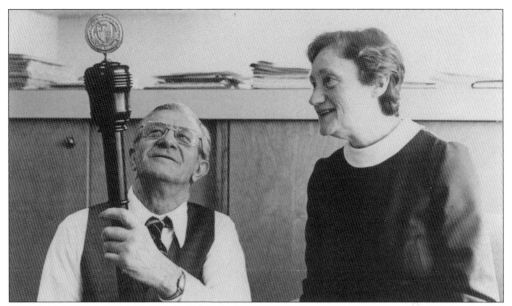

Carried for the first time in 1976, a ceremonial mace was designed and executed by Richard G. Moyer, a member of the college staff from 1947 to 1980. It was made of rosewood with the college seal at top, and red and gold ribbons. The mace was manufactured by Jacksons Ltd. of Pleasantville, New Jersey. A distinguished member of the faculty is designated yearly as the mace bearer and heads the academic procession at each year's commencement ceremony. Sr. Mary Colman is on the right.

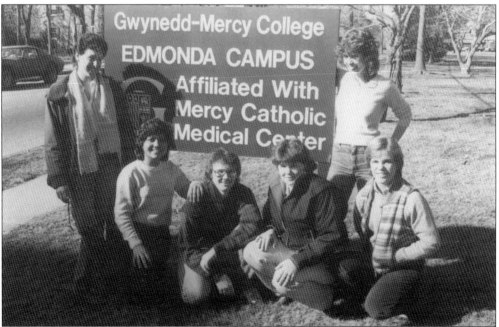

Gwynedd-Mercy College and Mercy Catholic Medical Center formed the Edmonda Campus in Darby, Pennsylvania, in 1979. This photograph records the open house celebration on June 7, 1980. Property was leased for classrooms, laboratories, offices, and residences for students.

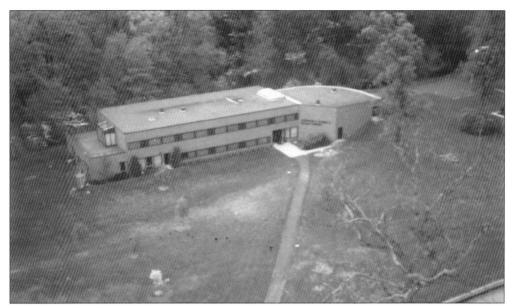

The Connelly Foundation, a philanthropic organization created by John F. and Josephine C. Connelly, contributed major funds for the construction of the faculty center. The building was named the Josephine C. Connelly Faculty Center in honor of the family's support. The first Connelly Student Scholarships were awarded in 1969; professional development grants for faculty also keep this legacy alive. For their generous support, the Connellys were named Life Members of the Crown and Shield Society.

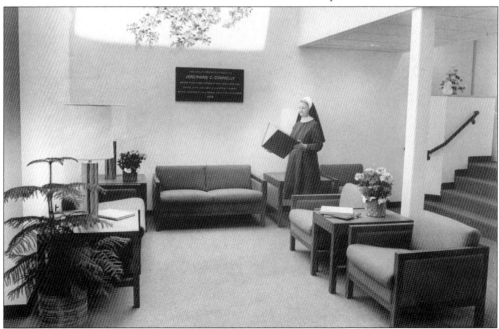

An open house was held in the Josephine C. Connelly Faculty Center the next year in 1979. Sr. Mary Rosamund Connelly, director of facilities at Gwynedd-Mercy College, stands in the main lobby of this new building in front of the plaque honoring Josephine C. Connelly, her sister-in-law.

The construction of the Genuardi Pavilion, which stands beside Gwynedd-Mercy College's outdoor pool, was supported by Frank O. Genuardi, a founding partner of the Genuardi Family Markets who was elected to the College Board of Directors in 1981. Since the 1980s, Genuardi and his family have remained devoted advocates of Gwynedd-Mercy College. In addition to service on the board of trustees and president's council, the Genuardis have supported major building campaigns and have come to embody the "joy of giving."

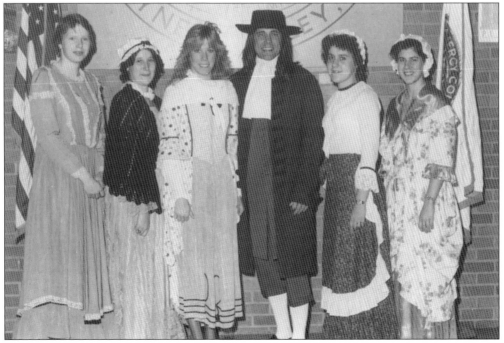

William Penn, portrayed by actor Erik Burro, visited the campus for the fall Honors Convocation in 1982. Here a group of students appropriately garbed in colonial costumes pose with the founding father.

Former Eagles player Bill Bergey chatted with Sr. Isabelle Keiss and Sr. Mary Joanna Regan during Gwynedd Day in 1982. Bergey was on campus, in part, to help raise funds for the planned expansion of Lourdes Library.

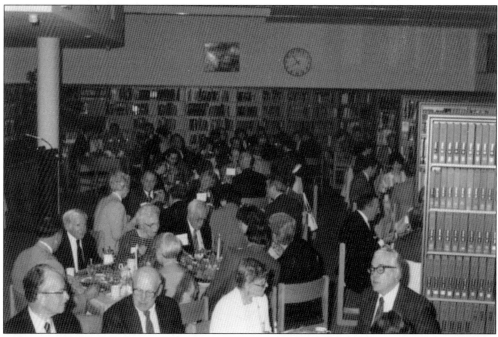

By September 22, 1983, the expansion was completed and all was ready for a formal library reception and dinner. This picture shows members of the college community dining at tables set up in the new reference area.

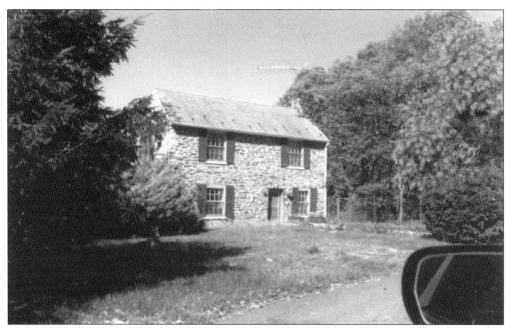

This residence, the former Charles Danenhower home, later occupied by Elizabeth Taylor Ely, and 8.14 acres were purchased in 1985 with the provision that Elizabeth Ely could continue to live on the property. She died the next year, in 1986, and the home became Tabor Convent.

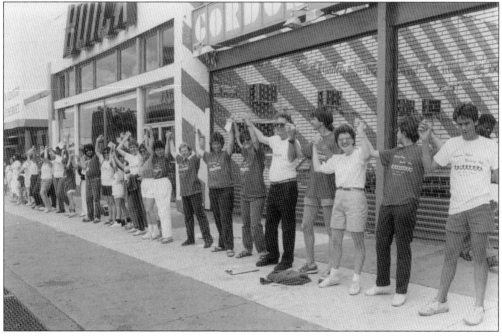

Hands Across America, a nationwide event during which people held hands and formed a human chain across the country, was celebrated by students, faculty, and staff of Gwynedd-Mercy College. This 1986 photograph captures a line of individuals wearing shirts that read "Gwynedd-Mercy Reaching Out" and raising their arms in enthusiasm.

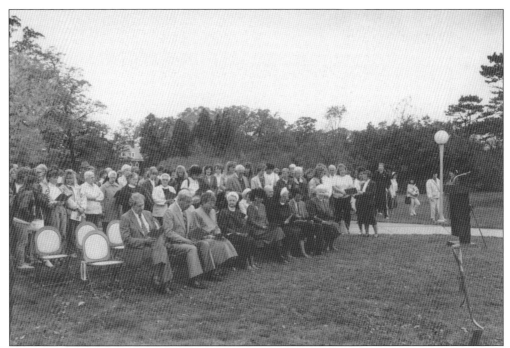

Gwynedd-Mercy College began the celebration of its 40th anniversary in the fall of 1987 with an athletic and conference center groundbreaking on October 23. Sister Isabelle is seated on the right with many members of the Connelly family in the front row.

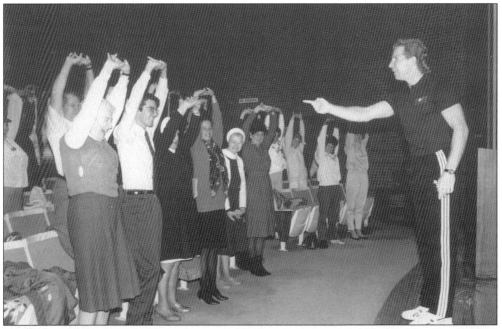

Pat Croce, Philadelphia personality and president of the Philadelphia 76ers basketball team from 1996 to 2001, was an honored guest during the groundbreaking festivities for the athletic and conference center. Here Croce leads the audience exercises in the Julia Ball Auditorium with Sister Isabelle and the Connelly family (front row).

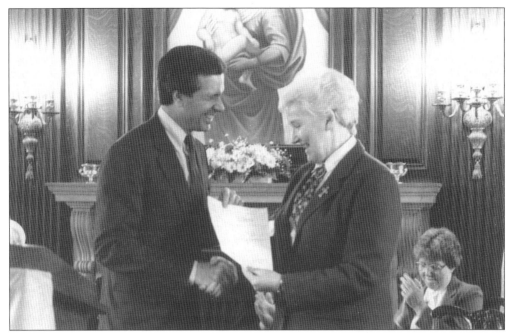

Sen. John Heinz (left) came to campus on May 6, 1988, and presented a check to Sister Isabelle for $277,000. Gwynedd-Mercy College had received a grant to assist in the recruitment of minority students into health careers from the federal Health Career Opportunity Program (HCOP). This program successfully continued until 2005.

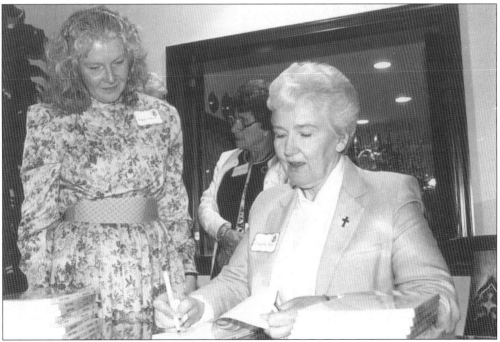

*Tender Courage: A Reflection on the Life and Spirit of Catherine McAuley, First Sister of Mercy* was published in 1988 by Sr. Mary Joanna Regan and Sr. Isabelle Keiss. Sister Isabelle is shown at a book signing held in June of that same year.

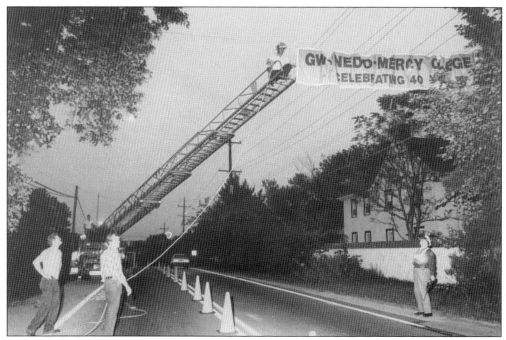

In September 1988, the Wissahickon Fire Department installed a banner over Sumneytown Pike, letting all who passed by know the Gwynedd-Mercy College was celebrating 40 years since the Sisters of Mercy came to the Gwynedd Valley in 1948.

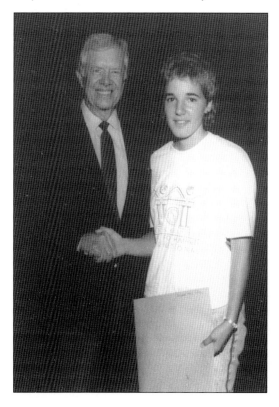

In 1988, Gwynedd-Mercy College received a charter membership in Habitat for Humanity from former president Jimmy Carter. Student Janine Azzarano accepted the charter from Carter.

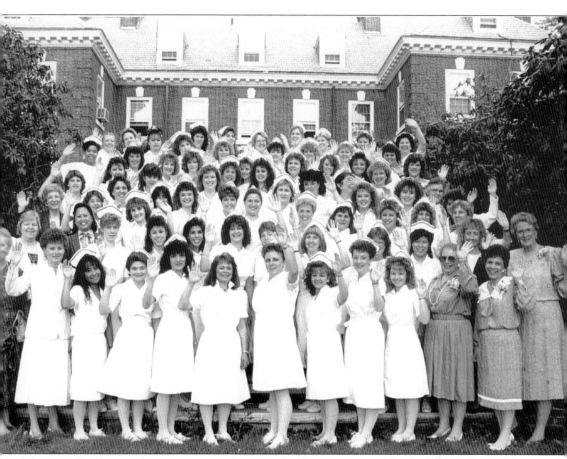

The 1988 Nursing graduates pose together outside of Assumption Hall. Flanking the students are the following faculty, from left to right, (first row) Ellen Driscoll, Judith Masiak, Arlene McMahon, and Marilyn Van Buren; (second row) Janet Gordon, Mercedes de la Cruz, Susan Cicione, and Jane Schultz; (third row) Barbara Hieman, and Eileen Pitone; (fourth row) Diane Wieland and Roseann Regan; (fifth row) Sr. Mary Rita Robinson.

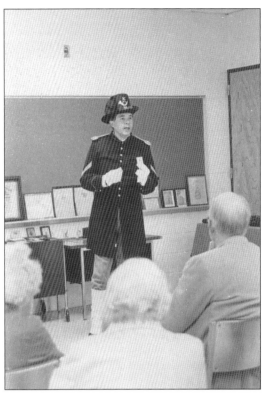

Wayne A. Huss, history professor and Civil War enactor, wears the dress uniform of a Union infantry private. Shown is a nine-button frock coat trimmed in light blue with brass shoulder scales, light blue trousers, a Hardee Hat, and white gloves. Equipment includes a .577 caliber Enfield musket with bayonet, leather cartridge box and strap, and waist belt with cap box. In addition to his teaching, he published a history of Whitpain Township in 2002.

Upward Bound teachers celebrate their 10th anniversary in July 1989. From left to right are Edis Schwartz, Molly Varghese, Robert Hahn, Mattie N. Lloyd, Debra C. Hobbs, Margie Winters, Mary Ward, and Stephanie Pease. This federally funded year-round college preparatory program targets 15 to 17 year olds and provides experiences that will assure success. In 2004, they celebrated their 25th year of operation.

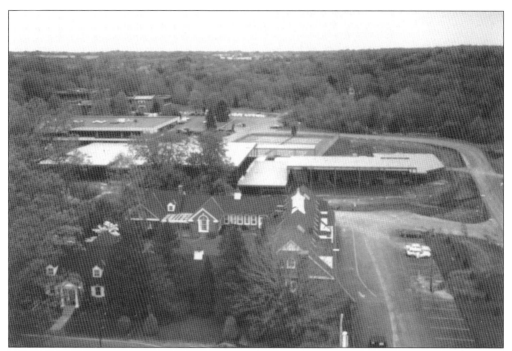

The old with the new: the athletic and conference center was constructed in the shadows of Byrne Hall, the converted stables that had initially housed the Sisters of Mercy's academy and junior college.

A competition to name the newly constructed athletic and conference center was announced. On February 12, 1990, winners Brenda Bingaman (far left) and Sister Marie Madeleine (second from left) were presented their awards for suggesting the name the Griffin Center. Presenting the winners with their awards were, from left to right, Josephine Connelly, her daughter Emily Connelly Riley, Sr. Mary Rosamund Connelly, and Sr. Isabelle Keiss.

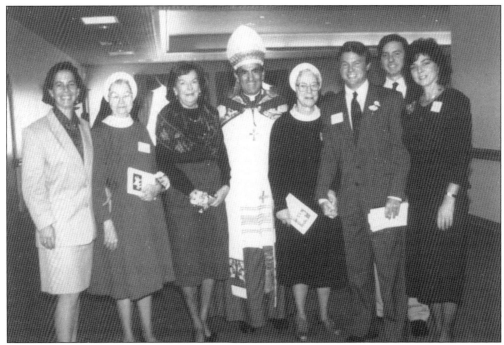

On April 5, 1990, the Griffin Center was dedicated. Cardinal Anthony Bevilacqua of Philadelphia (middle) attended with the Connelly family. During the dedication, Sr. Isabelle Keiss thanked the Connellys for their continued generosity and reminded the Gwynedd-Mercy College community that "If we can dream it, we can do it." John F. Connelly lived to see this building completed but died on July 8, 1990.

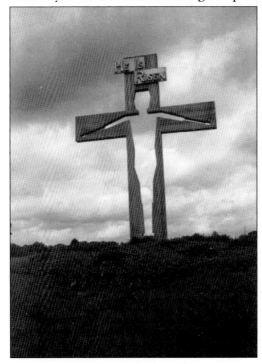

The Resurrection Cross, designed and donated by Jenkintown sculptor Jay Dugan in 1989, was a landmark at the entrance to the college on Sumneytown Pike. The cross was removed in 2004 due to significant deterioration.

A facsimile of the *Book of Kells* was presented to Gwynedd-Mercy College on March 4, 1990. The original copy, written around AD 800 by Irish monks, has been at Trinity College in Dublin since 1661. It is a hand-illuminated presentation of the Gospels of Matthew, Mark, Luke, and John. Sr. Isabelle Keiss (second from left) received this gift from Richard Torpey (second from right), president of the Friendly Sons of St. Patrick.

In the early 1990s, Gwynedd-Mercy College entered into a cooperative agreement with Allentown College (now DeSales University) to offer a masters in business administration program at the college. Courses were taught by faculty from both institutions. Here Sister Isabelle signs the proclamation with Fr. Daniel Gambet of Allentown College.

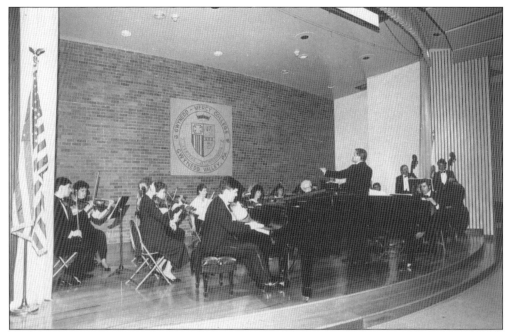

Also in the early 1990s, Gwynedd-Mercy College sponsored an artist-in-residence program. One such artist was William Carr, a pianist. Here Carr performs in a spring 1991 "Tribute to Mozart" with the Philadelphia Chamber Players, a 32-member group directed by Roy V. Cox. Cox, a resident of Philadelphia, conducted the Ambler Symphony at the time.

This image captures the 1990 production of Carol Night, an annual Christmas concert and college tradition, performed by the college's choir. This particular year the show had an international theme, as evidenced by the costumes.

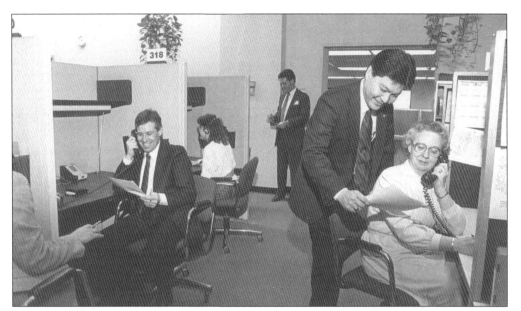

TELERx Marketing of Spring House, Pennsylvania, donated telephone marketing services for Gwynedd-Mercy College's 1991 annual fund appeal. Ruby Clouse (on right) was a member of the alumni board, and Gerald McLaughlin (to the left on the phone) was director of annual fund giving. Annual phonathons continue to be a popular way to connect with constituents and grow the annual fund.

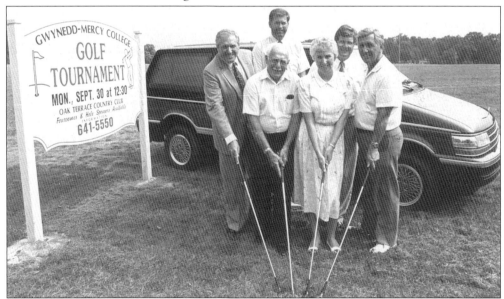

The Fifth Annual Golf Tournament, another popular fund-raising activity, was held on September 30, 1991, at Oak Terrace Country Club. From left to right are (first row) John Knowles, executive vice president of Posse Walsh Incorporated, tournament chair; Frank Genuardi; Sr. Lois McDonough, Gwynedd-Mercy College's vice president for development; and Dan Ritter, president of Beautyguard Manufacturing Company; (second row) Mark Craney, vice president of Crescent Vending Company; and Jay Haenn, president of Lansdale Chrysler-Plymouth.

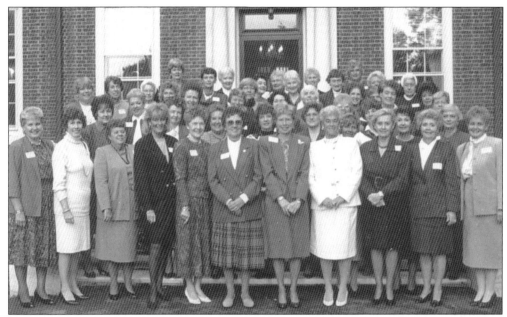

All alumni classes of the 1950s returned to campus in October 1991. Over 6,000 alumni were contacted that year with an increase of 26.4 percent in giving. Members of various classes pose on the steps of Assumption Hall during their reunion.

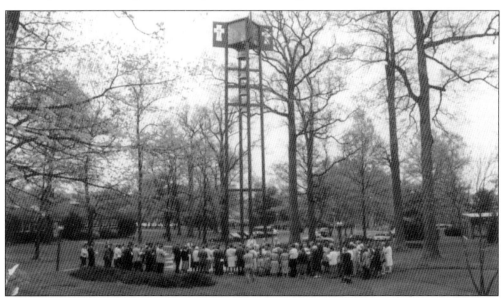

The dedication of the bell tower took place on Thursday, May 6, 1993. Designed by architect David Edward Zays and fabricated by Joseph P. Mascaro and Sons, the tower is 62 feet high, just less than 13 feet wide at its widest point, and weighs eight tons. It is made of steel painted a deep bronze and has four bells and a loudspeaker system for an electronic carillon. The bells, cast in the Netherlands, were installed by Schulmerich Carillons Incorporated. Donated by Joseph P. Mascaro, a president's council member, two of the four bells are dedicated to Mascaro's wife and mother, one bell is dedicated to Mother Mary Bernard Graham, and the fourth to the Virgin Mary.

Cocurricular activities are an important part of a student's experience at Gwynedd-Mercy College. Many events on campus are planned to provide spiritual enrichment and allow students to fully experience the mercy mission and values. This September 1992 picture shows students talking with Maria McHugh, of the physical education department, and gathering information about peer counseling and Campus Ministry.

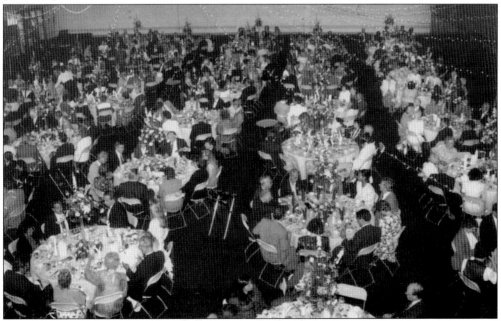

In 1993, Sr. Isabelle Keiss resigned as president to assume a position with the Mercy Health Corporation. A gala retirement dinner was held in the Griffin Center to honor her retirement from the college and a Scholarship Endowment Fund was set up in her name. Sister Isabelle passed away one year later on September 24, 1994.

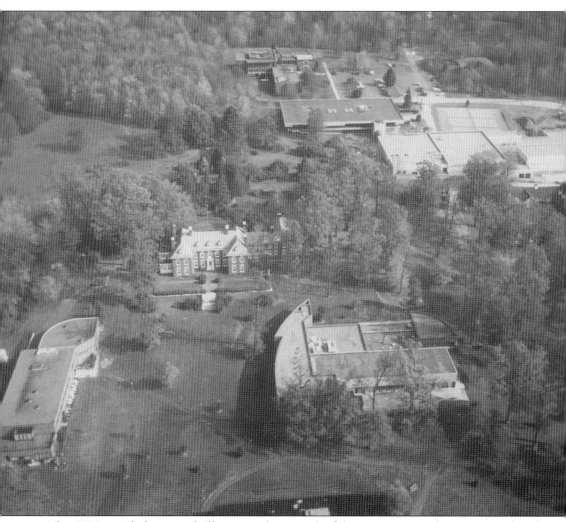

This 1990 aerial photograph illustrates the growth of the campus over the years. Landmark buildings such as Assumption Hall (center) and Byrne Hall (center right) are nestled between newer buildings such as the Connelly Faculty Center (left) and the Griffin Complex (top right). Further expansion is yet to come.

## *Six*

# THE MERCY LEGACY:
## 1994 AND BEYOND

The next chapter of Gwynedd-Mercy College's history began with the 1994 inauguration of the fourth president, Sr. Linda Bevilacqua, OP (Dominican designation, Order of Preachers), Ph.D. Under Bevilacqua's guidance, the college's physical and academic landscape continued to experience significant growth. Academic programs were augmented by articulation agreements with institutions such as Pierce College, LaSalle University, Bucks County Community College, and Montgomery County Community College. The college also opened the Center for Lifelong Learning in Fort Washington, Pennsylvania; the Sister Isabelle Keiss Center for Health and Science; St. Brigid and Siena Halls (two residence facilities); and the Valie Genuardi Hobbit House during Bevilacqua's tenure.

This was also a time of renewal, beginning with the restoration of the Lady Garden in 1995 and that of the Lady Garden's Blessed Mother statue in 1999, courtesy of enthusiastic Gwynedd-Mercy College alumni. The college observed its 50th anniversary in 1998, celebrating its past while looking to its future. In 2001, the Rotelle family spearheaded a major refurbishment of the interior first floor of Assumption Hall, restoring the building to a grandness that honors its famous architect, Horace Trumbauer, and the original owners, the Bonds.

The history of the college and the contributions of important friends of the institution were celebrated during several book signings in the 1990s. David Contosta published *The Private Life of James Bond,* and Bond's widow, Mary Bond, graced the campus once again in 1994. Frank Genuardi, an emeritus member of the board of trustees signed copies of his autobiography *Family Pride: A Memoir*, and Pat Croce, local Philadelphia personality, came to campus once again to promote his book, *I Feel Great and You Will Too.*

The college's fifth president, Dr. Kathleen Cieplak Owens, was installed in 2002. Owens, the first layperson to become president, heralded in an era of new vision. Record enrollment, a trend begun in Bevilacqua's time, has continued under Owens's leadership. Cocurricular activities and athletics continue in popularity, and in 2005, the college unveiled a new mascot—M.E.R.V. the griffin. Due in part to burgeoning enrollment, a new residence facility, Alexandria Hall, opened in January 2006.

The new millennium continues to be an era of change. The college's latest strategic plan unveils a vision to become "The Beacon for Mercy Education in America," and Gwynedd-Mercy College has mobilized to heed that call. In addition, the Institute of the Sisters of Mercy of the Americas has announced a major reorganization, which will have an ongoing effect on the college and its sponsors.

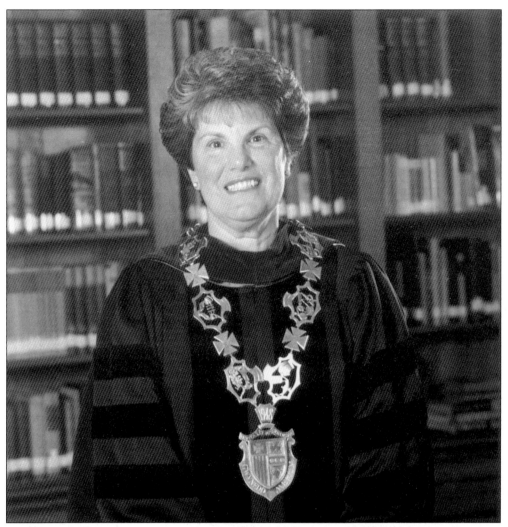

Linda Mary Bevilacqua, OP, Ph.D., fourth president of Gwynedd-Mercy College, arrived on campus in August 1993 to assume her duties and was installed as president in September 1994. A 1962 graduate of Barry College, she entered the the Dominican Community of Adrian, Michigan, that same year and went on to earn her doctorate at Michigan State University. In this portrait, Sister Linda wears the Chain of Office, created in 1982 by internationally known gold and silversmith Kurt J. Matzdorf. The chain is 46 inches long and made of sterling silver and acrylic. The medallion carries the college coat of arms and the motto "Veritas et Misericordia." The chain itself consists of 10 frames alternating with nine Mercy crosses.

Nursing instructor Jean Michiels looks on as Frank Bruno showed a young patient how easy inoculation is. This was part of the Immunize Children at Risk Early (ICARE) immunization program, delivered at St. Malachy Parish in Philadelphia. This photograph illustrates Gwynedd-Mercy College's continuing relationship with this parish, the Sisters of Mercy tradition of providing quality health care, and the Mercy mission of service to society.

Annually, the students of Gwynedd-Mercy College participate in field day for the children of St. Malachy. The day is filled with games and contests including sack races and, of course, face painting. This is one of the many ways the college community keeps its ties with a parish that was historically significant for the Sisters of Mercy.

In celebration of Valentine's Day, the Voices of Gwynedd sell "Singing Valentines" across campus. Choir members place telephone calls to patrons' loved ones and serenade them with a variety of tunes. This early photograph catches some of the choir members in action.

Each year, faculty don their academic regalia for Gwynedd-Mercy College's commencement ceremony. In 1997, academic restructuring resulted in the creation of five separate schools: the School of Arts and Sciences (which houses the Departments of Behavioral and Social Sciences; the Department of Humanities; the Department of Language, Literature, and Fine Arts; and the Department of Natural Science and Math); the School of Allied Health Professions; the School of Business and Computer Information Sciences; the School of Education; and the School of Nursing.

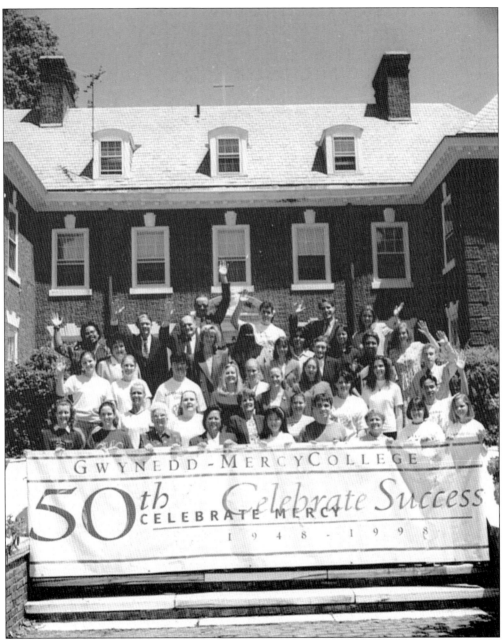

In 1998, Gwynedd-Mercy College celebrated its 50th anniversary. The yearlong festivities included various lectures and concerts, a trip to Ireland, a special address given by Cardinal Anthony Bevilacqua, and a gala anniversary dinner at the Blue Bell Country Club on November 6, 1998.

The 50th anniversary gala was attended by faculty, staff, alumni, and friends of Gwynedd-Mercy College. An evening of dining, dancing, and merriment was on tap. Here Sister Linda poses with the evening's student "hosts." In addition to honoring the Sisters of Mercy, awards were presented to Robert Kelly, a member of the board of trustees, and the Connelly family. The event raised funds for the construction of Keiss Hall.

The Sister Isabelle Keiss Center for Health and Science was constructed to honor the third president of the college. Guests who attended the groundbreaking on June 3, 1998, included, from left to right, Rick Stoudt, Robert Kelly, Sister Linda (Gwynedd-Mercy College president), William Avery, James Schleif, Frank Genuardi, and Joe Abramson.

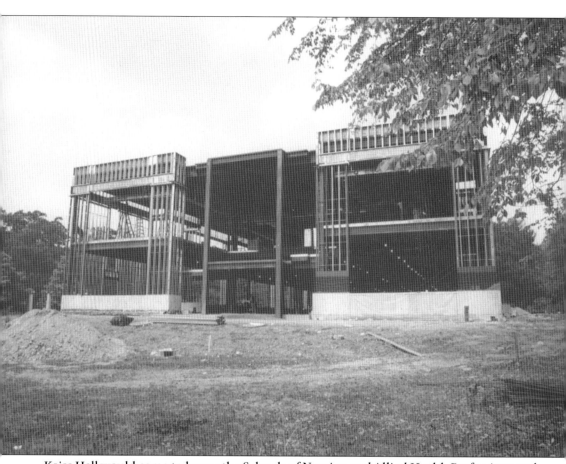

Keiss Hall would come to house the Schools of Nursing and Allied Health Professions and the Division of Natural Science and Mathematics and provide much-needed classroom and laboratory space. This new facility was completed and dedicated in 1999.

Completed in January 2000, St. Brigid was the second on-campus residence hall to be constructed at Gwynedd-Mercy College. The growing enrollment that necessitated the construction of this hall would continue, prompting an almost immediate need for a third new facility.

Valie Genuardi, Linda Belivacqua, and Frank Genuardi pose with a thank-you card handcrafted by the students of the Valie Genuardi Hobbit House at the June 13, 2000, dedication of the building. This child development nursery school began in 1974 on the grounds of Gwynedd-Mercy College and was originally housed in Byrne Hall. The new facility was greatly appreciated by all.

In July 2000, the first floor of Assumption Hall underwent extensive renovations. Upon completion (below), Assumption Hall would be featured in the Fall 2001 issue of *Montgomery County Town and Country Living*. The restoration entailed the stripping, sanding, and varnishing of the floors and paneling, and the cleaning and repair of the 17-foot-by-34-foot antique Sarouk carpet, originally a gift from Misericordia Hospital. The interior was completely repainted, and ceilings were repaired. Design Express of Blue Bell did the interior decorating, which included the wallpapering of the dining room, and new furniture, draperies, rugs, and lighting for each room. Outside, the brick and marble on the front steps were removed, repaired, and reconstructed. The restoration was finished in early October.

Siena Hall, a third residence facility and the second to be built in as many years, opened in August 2001 to accommodate the continually growing resident population. This facility was named for St. Catherine of Siena, in honor of Sr. Linda Bevilacqua's Dominican order. Sister Linda stepped down as president at the end of the 2001–2002 academic year.

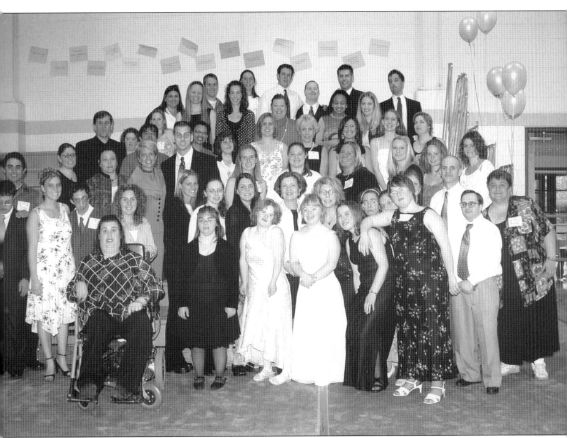

Best Buddies, an international organization whose mission it is to enhance the lives of people with disabilities, is a thriving student organization on campus. The college members of Best Buddies are paired with individuals from the community who have special needs for the purpose of friendship and socialization.

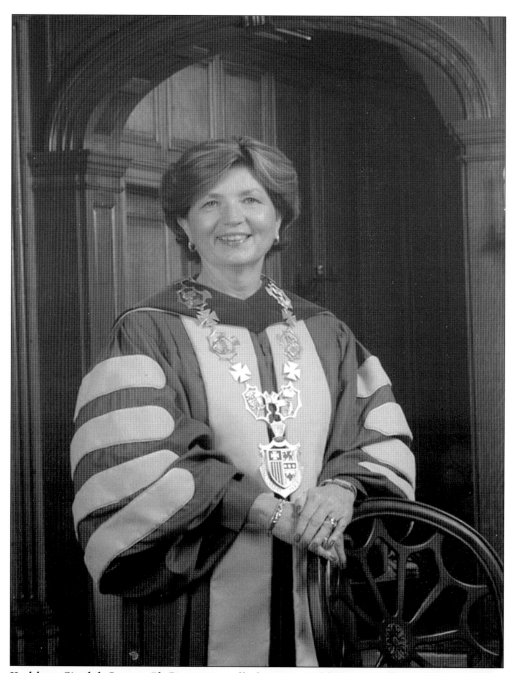

Kathleen Cieplak Owens, Ph.D., was installed as Gwynedd-Mercy College's fifth president on April 5, 2003. A native of Chicago, Owens graduated from Little Flower High School and went on to receive a bachelor's degree in biology from Loyola University. She received her master's degree from DePaul University and returned to Loyola for her doctorate. Owens worked previously as a biology teacher in the Chicago public schools, as the dean of the College of Arts and Sciences at Lewis University in Romeoville, Illinois, where she also chaired the education department, and as the vice president for academic affairs at Saint Francis University in Loretto, Pennsylvania.

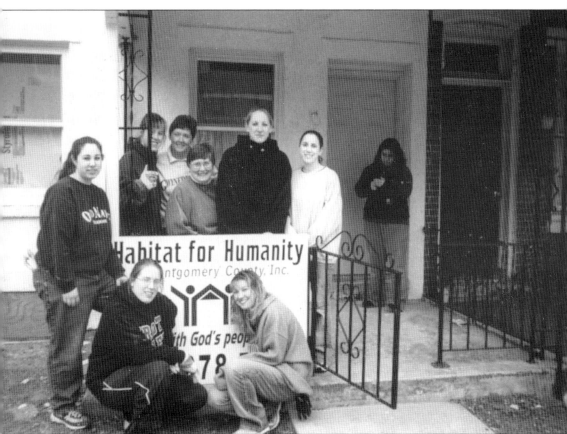

At orientation, Gwynedd-Mercy College students are introduced to a hallmark of Mercy education—service to society. Volunteering with Habitat for Humanity has been popular on campus since the college received a charter membership from Jimmy Carter. Pictured here, from left to right, are (first row) Susan Newman, Nicole Paperman, and Kristin Biles; (second row) Lauren Dunn, Sr. Beth Flannery, Sr. Carol Tropiano, Heather Hogga, and Jacklyn Morrison.

A new tradition in service began in 2002 when the Voices of Gwynedd participated in the opening ceremonies of the Susan G. Komen Race for the Cure. The Voices of Gwynedd raise spirits at this annual event as they entertain the crowd from the steps of the Philadelphia Museum of Art.

In 2003, Gwynedd-Mercy College welcomed to campus Charles Madden, creator of the magnificent stained-glass window that gives the Campbell Hall chapel its serenity and beauty. Madden spoke to the college community about his inspiration for the piece, his choice of color, and what the stained glass signifies. Madden is pictured here with Dr. Owens.

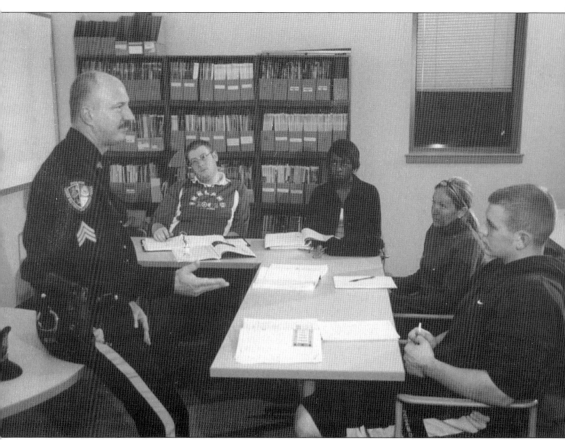

New programs continue to be added to the curriculum at Gwynedd-Mercy College. For example, the Behavioral and Social Sciences Division began offering a bachelor of science degree in criminal justice in 2003. With a comprehensive program that focuses on corrections, the courts, and law enforcement, students enter the workforce after graduation and qualify for a variety of positions, such as police officers, corrections or parole officers, and private security professionals.

In 2005, M.E.R.V. the griffin, the half-eagle/half-lion symbolizing Gwynedd-Mercy College athletics and school pride arrived on campus. M.E.R.V. stands for Mercy Education, Rigorous intellect, and Valuing diversity—key components of the college's mission and values.

As Gwynedd-Mercy College held its 56th commencement on Saturday, May 14, 2005, the number of graduates surpassed previous years, with more than 700 students receiving their associate's, bachelor's, and master's degrees. Here graduates of the Center for Lifelong Learning await their turn to receive their degrees.

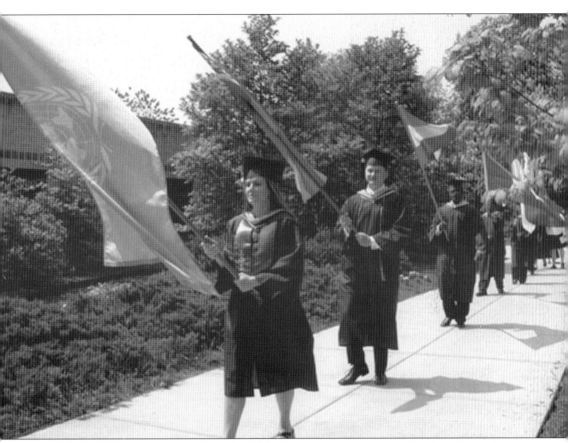

As is tradition, students process into the 56th commencement ceremony bearing various international flags, as well as the flag of the United Nations (left). Often, international students can be seen carrying the flags of their homelands.

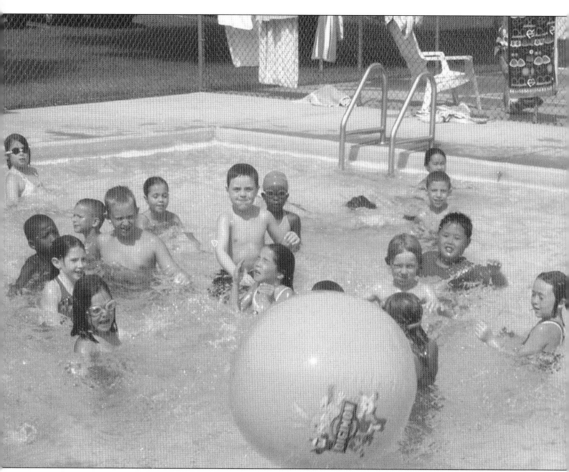

The Gwynedd-Mercy College Day Camp celebrated 50 years of service in 2005. Originally named Treweyrn Day Camp, the camp began in 1954 and has grown to be one of the most popular day camps in Montgomery County. The camp is designed to provide a healthful atmosphere where each camper can enjoy a wide variety of activities while practicing the values of respect for others, honesty, and good sportsmanship.

The Merion Regional Community of the Sisters of Mercy began Mercy Volunteer Corps in 1978 and enthusiastically supported Mercy Volunteer Corps through all its initial years. When the Institute of the Sisters of Mercy of the Americas formed in 1991, the Merion Regional Community Leadership believed that Mercy Volunteer Corps should become a sponsored work of the institute. The Mercy Volunteer Corps, currently housed on the Gwynedd-Mercy College campus, celebrated its 25th anniversary with a gala at the Merion Motherhouse in 2003.

At the 2005 commencement ceremony, Dr. Owens (second from left) bestowed honorary degrees on the three past and present directors of Mercy Volunteer Corps: Sr. Ellen Cavanaugh; Sr. Kathleen Lyons (right); and Sr. Eileen Campbell (left). All three received honorary doctor of humane letters degrees for their work.

In January 2006, Alexandria Hall, Gwynedd-Mercy College's fourth residence facility, opened to students. Named for St. Catherine of Alexandria, the patron saint of students, this 204-bed facility offers students three separate living arrangements and many state-of-the-art amenities. The construction of this facility is evidence of the ever-burgeoning resident student population at Gwynedd-Mercy College.

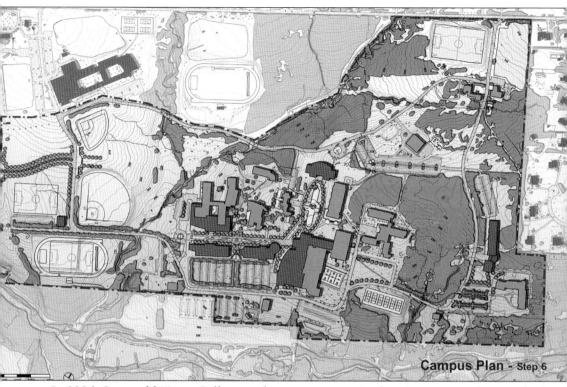

Campus Plan - Step 6

In 2004, Gwynedd-Mercy College underwent a strategic planning process that resulted in a clear vision for the future. As Gwynedd-Mercy College strives to become the "Beacon for Mercy Education in America," the college has assessed both its needs and its goals. From this planning, a campus master plan was commissioned and was completed in the fall of 2005. This document provides a plan for directed growth over the next 20 to 25 years.

# BIBLIOGRAPHY

Bond, Mary Wickham. *How 007 Got His Name.* London, England: Collins Publishing, 1966.

Bush-Brown, Louise and James Bush-Brown. *Portraits of Philadelphia Gardens.* Philadelphia, PA: Dorrance and Company Publishers, 1929. (PP 77–81).

Centennial Committee. *Lower Gwynedd Township—A Pictorial Guide to Some of Its Older Buildings.* (Privately published), 1991.

Congregation of the Religious Sisters of Mercy. *A Century of Mercy, 1861-1961.* Philadelphia, PA: Privately published, 1961.

Connelly, M. Henrietta. *Mother M. Patricia Joseph Waldron—Founder and Superior of The Philadelphia Sisters of Mercy, 1861-1916.* Devon, PA: Cooke Publishing Company, 1986.

Contosta, David R. *The Private Life of James Bond.* Lititz, PA: Sutter House, 1993.

Gwynedd-Mercy Academy High School. *The Gwynedd Almanac—Anecdotes Lovingly Preserve History.* Ivyland, PA: Gero Graphics, 1996.

Jenkins, Howard Malcolm. *Historical Collections of Gwynedd.* Philadelphia, PA: Ferris Brothers, 1884.

Mercy International Association. *Sisters of Mercy.* Strasbourg, France: Editions du Signe, 1996.

Regan, RSM, Mary Joanna and Isabelle Keiss, RSM. *Tender Courage—A Reflection on the Life and Spirit of Catherine McAuley, First Sister of Mercy.* Chicago, IL: Franciscan Herald Press, 1988.

Ruth, Phil Johnson. *Fair Land, Gwynedd—A Pictorial History of Southeastern Pennsylvania's Lower Gwynedd Township, Upper Gwynedd Township, and North Wales Borough.* Souderton, PA: Indian Valley Printing, Ltd., 1991.

# INDEX

## ACROSS AMERICA, PEOPLE ARE DISCOVERING SOMETHING WONDERFUL. *THEIR HERITAGE.*

Arcadia Publishing is the leading local history publisher in the United States. With more than 3,000 titles in print and hundreds of new titles released every year, Arcadia has extensive specialized experience chronicling the history of communities and celebrating America's hidden stories, bringing to life the people, places, and events from the past. To discover the history of other communities across the nation, please visit:

# www.arcadiapublishing.com

Customized search tools allow you to find regional history books about the town where you grew up, the cities where your friends and family live, the town where your parents met, or even that retirement spot you've been dreaming about.